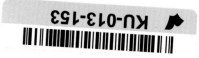

Plastic

Materials for Inspirational Design

Chris Lefteri

RotoVision

A RotoVision Book
Published and Distributed
by RotoVision SA
Rue Du Bugnon 7
1299 Crans-Près-Céligny
Switzerland

RotoVision SA
Sales and Production Office
Sheridan House
112–116a Western Road
Hove, East Sussex, BN3 1DD, UK
Telephone: +44 (0)1273 72 72 68
Facsimile: +44 (0)1273 72 72 69
E-mail: sales@rotovision.com
Website: www.rotovision.com

Copyright © RotoVision SA 2001

All rights reserved. No part of this publication may be
reproduced, stored in a retrieval system or transmitted
in any form or by any means, electronic, mechanical,
photocopying, recording or otherwise, without permission
of the copyright holder.

10 9 8 7 6 5 4 3 2 1

ISBN 2-88046-548-6

Original series concept by Zara Emerson

Book designed by Frost Design, London

Production and separations by
ProVision Pte. Ltd. in Singapore
Telephone: +65 334 7720
Facsimile: +65 334 7721

Printed and Bound in China by Midas Printing

10 051924

Luton Sixth Form College
Learning Resources Centre

745.4

Luton Sixth Form College
Learning Resources Centre

745.4

Plastic

WITHDRAWN

10051924

This book is dedicated to my parents and to the memory
of my grandparents Efrosini and Toffali Nicola.

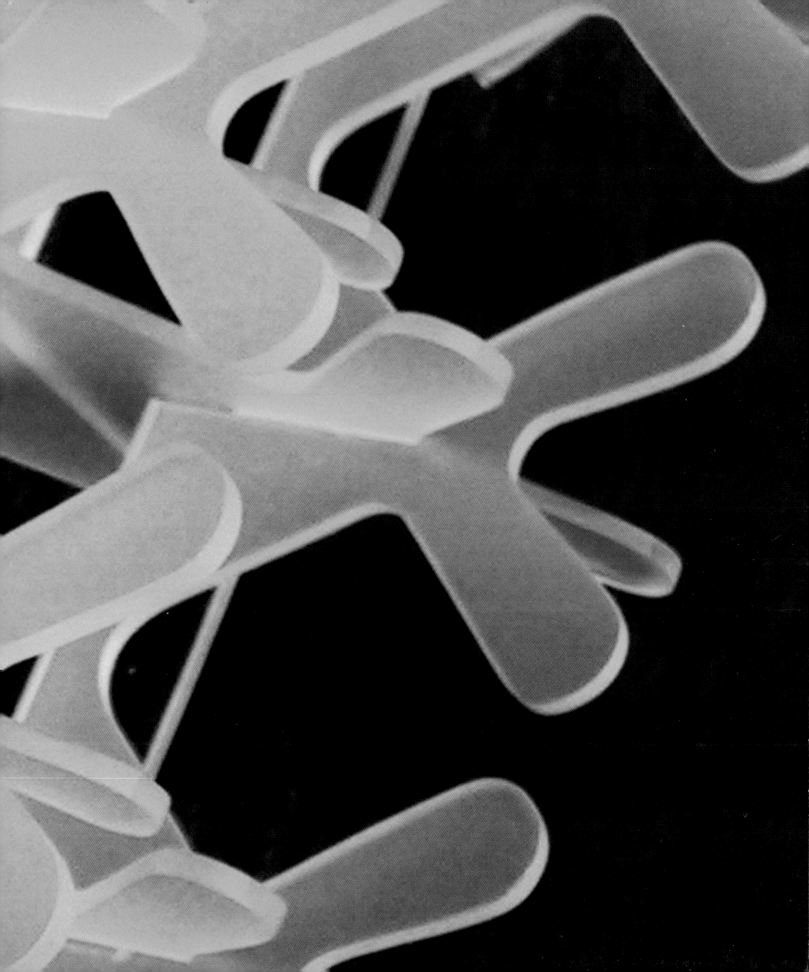

Contents

Skin knows when it is broken
Skin can breath, but it is also waterproof
Skin can heal itself when it breaks
Skin changes pattern and texture
across its surface
Skin has sensors on every part of itself
that can detect pressure
Skin comes in amazing patterns and colours
Skin smells if you don't take care of it
The pattern of the skin on our fingertips is
never, ever the same

We are only at the beginning of our exploration
into materials. Our ability to manipulate and
control metals, wood and ceramics is thousands
of years old but the invention of plastic is little
over a hundred years old. Our ability to change
a material's form, its chemical composition and
its physical properties is as exciting as any of the
new technologies that are being investigated today.

It is too obvious to say that materials surround
us — they are at the basis of our existence. We
appreciate the design of objects through those
familiar terms, form and function. Yet it is the
application of the material and its use as part
of a specific object and function that often goes
unnoticed. Evidence of the miracle of these
materials is everywhere, from 'Gods material',
wood, which creates its own unique structure
and identity based on thousands of years of
evolution, to glass, a liquid that moves so slowly
that its movement is invisible. Both these
materials have their own concept of time.
Plastic, the material that is defined by its ability
to transform its shape, is an infant in relation
to these 'older' materials.

At college designers are taught about materials
as a separate subject. This is not wrong,
because there should be formal tuition in this
highly complex and diverse area; the basics of
what materials are, what they can do, how they
are produced and how they are processed.
However, the design process does not always
dictate that the material is considered separately
after the form and function have been drawn up.

Many designers, artists, architects and
manufacturers make specific materials their
trademark. They are known for exploring, pushing
and innovating in a given material. Others are
known for their ability to manipulate and discover
using a whole range of materials. Either way
they are able to take a material and to look at it
through the eyes of a child; to take it apart in
order to find out what it really is and what it can
do. It is this child-like curiosity inspired by seeing
inks that glow in the dark, or plastic spoons and
t-shirts that change colour when you touch
them that drives ideas. Yet these things are
around us everywhere we turn and are so
familiar and in such abundance that they are
almost invisible. In our constant search for new
materials we ignore the familiar. There is a
quote that I have always appreciated that says,
'If you have lemons, make lemonade', but the
really exciting moments come when you have
lemons and you make an ice-lolly.

This book on plastic is the first in a series; later books will include glass, ceramics, rubber, foam, wood and metals. The purpose of the series is to explore and present materials in a common language that explains their characteristics, benefits and uses, and to present them in a stimulating format with examples of their use. This series is a celebration of these miracles of evolution and technology — an exploration into objects and materials that have been around for thousands of years and those that are being discovered now.

Foreword

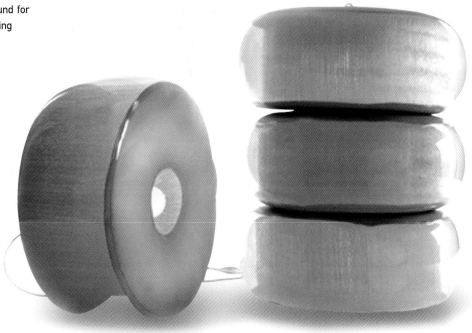

My curiosity has always led me on a straight-forward process of discovery; I would never read about the objects that fascinate me, but instead use a hammer to break them open. It's that curiosity that incites a child to use a screwdriver to open up and dissect their mother's vacuum cleaner, or deliberately to cover their hands in PVA glue just so they can peel it off. I have always wanted to know about products — how they are made, what's inside them, what they are made from. As a boy I used the hammer for this process of discovery, breaking apart simple things like stones, old telephones and golf balls. I liked to see how strong these things were and what was inside. Finding a lost golf ball was one of the best things. The hammer didn't work so I cut through its tough skin, and after struggling to open it, was amazed that all that was inside was a lot of elastic bands. So I cut through the elastic bands which resulted in this explosion of 'stuff' in my face. This is the curiosity that makes people grow up into designers.

This book is my big chance to find out about 77 products. Having restrained myself with the hammer the book focuses on one specific material, plastic. This is not to say that I have a specific obsession with plastic. Nor am I singing the praises of plastic over any other material. I have chosen plastic because it is one of the most diverse and widely used materials today. It is relatively young compared with glass, wood and ceramic, but within about 100 years it has grown into an enormous range of diverse materials with thousands of properties and uses, with an unfathomable availability of research and information. As an example, if you type 'plastic' into the Alta Vista search engine you will get over two million results. One of the largest chemical companies in the world produces so many polymers that no-one in the company knows exactly how many they do produce. This book is as much a pursuit of curiosity as of trying to

rationalise on a basic level a sample of materials that fall under the term plastic. But more than satisfying my own curiosity this book is a companion for anyone interested or involved in the design of plastic. It is not a historical analysis of plastic and plastic products, but instead serves to be an aid to understanding more about the hundreds of plastics we use every day.

Over the last century this material has developed far more than any of the other traditional materials that have existed for thousands of years, creating an enormous range of possibilities. Plastics fulfil so many of our everyday needs; they fill every room of the house, the car, the office and our leisure time. They give us new physical and practical advantages and fulfil our visual and emotional needs. Plastic parts in medical care allow human organs to be replaced by artificial ones. At the same time plastics are accompanied by feelings of ecological disaster; busy streets overflow with discarded plastic packaging and natural resources are over-used in their manufacture. But these are the questions that some producers are dealing with — how we recycle our waste into new forms and how we can use alternative natural starting points.

My aim was to include objects and materials that we are all familiar with. Some of the items were chosen because they are great materials, others because they are intelligent uses of plastic, some because they are fun and some because I wanted to find out about them, like the Ping-Pong balls that are made from Nitrocellulose which is so explosive they are not allowed to be transported by air. However, this material which has been around for 100 years is the only material that will do the job.

I have also tried to cover all areas of design and production from products made as one-offs, to those mass-produced, ten-million-units-a-year products. From high design pieces to some

of the everyday objects whose origination is unknown. It includes the works of Gaetano Pesce and Droog whose working methods are closer to the artisan than to that of mass-production. It includes exciting and intelligent materials like Rolatube™, a strip of composite material that can be held in a coiled position and unrolled to form a rigid tube. Also included are designer/manufacturers like Kartell and Alessi who use the material to produce design-led products. Many of the products are innovative because of the production methods used like Ron Arad's 'Not Made by Hand, Not Made in China'; others illustrate simple changes of context for a material as in the Pet Shop Boys' 'Very' CD case.

But this book is not just about what plastic is and what it can do. Certainly it has great potential to do whatever you want it to chemically and physically and this has not been ignored, but I also want to describe the effects it has on our senses. Plastics offer something for all our senses, like the smell when opening the box of a piece of a hi-fi, computer or a new car; the tactile, waxy feel of Tupperware®; the translucent, visual quality of a piece of polypropylene; the 'ping' and the 'pong' sound of a table-tennis ball; and the taste of a plastic spoon — although you should never be able to taste plastic unless someone is not doing their job properly.

As a designer I am also interested in exploring materials and their uses in new areas of design. What are the potential design outcomes if the material is the starting point and not a form or function? Designers like Bobo Design work with acrylic to find new applications and functions; Fiona Davidson and Gitta Gschwendtner, working for DuPont, seek to find new ways of using Corian®. Hopefully this series will encourage a little curiosity, not just for the things that are already there, but for finding new applications for the things that could be there.

Preface

How to use this book

The book is divided into two sections. In the first section each page relates to a specific object within a given product context. Pages are divided into three layers of information, containing the basic details of the object. The text is deliberately non-technical. My purpose is not to swamp the page with technical information which in most cases is not of great interest, but to inform in a common language which hopefully suggests to the reader new ideas for materials and products. If a traffic cone can bounce back to shape after a ten-tonne lorry has driven over it, what is the potential that the material, polyethylene, has in a different context?

It is impossible to separate the material from the manufacturing process and therefore materials appear more than once in the book, showing the diverse ways that they are processed and offering suggestions for why one process is more appropriate than another. Polypropylene, for example, which in its moulded form has been in use since the 1950s, has only in the last ten years been fully exploited as a flat-sheet material; in terms of tooling costs it is greatly reduced by the use of die-cutting tools. Some of the pages focus on a material like ABS; some focus on a specific company's material like Rolatube™; others focus on applications like bowling balls. None of the companies featured have sponsored the book in any way.

The book cannot tell you everything you need to know about plastics but it aims to offer a taste for a broad selection of materials. Each product or material featured is accompanied by further information. If it is not given it is because we were asked specifically not to include it. Although the contact details are given on each page this is only a guide. In most cases they are by no means the only suppliers of the material. A reference guide is also included on each page to cross-reference subjects on other pages. The Appendices also provide a broader reference guide including websites and organisations, all with a wealth of relevant information. There is also a technical table for a ready comparison of the detailed physical properties of each plastic, a description of manufacturing processes, a list of plastics abbreviations and a glossary of technical terms.

013 Big

014

Waxy texture

Polyethylene ➘ is making a comeback. With a waxy feel like Edam cheese, it has none of the subtle, matt, sophisticated texture of, for example, a polypropylene ➘ product by Authentics ➘. Polyethylenes are characterised by easy processing, chemical resistance and a balance between impact, strength and stiffness, which is why the material is an ideal choice for large components in children's toys.

It appears to be a popular material amongst contemporary designers. The UK company Inflate ➘ and the designer Tom Dixon have both realised the potential of rotationally-moulded polyethylene. The low investment in tooling means that large-scale, low-volume goods can be mass-produced without the initial capital investment that is required from processes like injection moulding.

Designed for his final-year exhibition at the Royal College of Art, Rainer Spehl's Qoffee stools highlight perceptions of value, familiarity and scale. The design is a simple twist of scale, surprising us with a new form of an everyday familiar and disposable object.

more: Polyethylene 015–016, 034, 038, 053, 105, 107, 113, 116, 125; Polypropylene 015–016, 025, 037, 045, 049, 061, 070, 083, 107, 109; Authentics 045, 070–071; Inflate 051

Dimensions	**47 x 35cm; weight 1.2kg**
Production	**Rotationally-moulded polyethylene**
Material Properties	**Excellent resistance to chemicals**
	Well balanced relationship between stiffness, impact strength and resistance
	Low moisture permeability
	Recyclable
	Colourfast
	Low cost
	Easy to process
Further Information	**www.excelsior-roto-mould.co.uk**
	www.rotomoulding.org
Typical Uses	**Chemical drums; carrier bags; flexible toys; car fuel tanks; cable insulation; furniture**

Qoffee stool
Designer: Rainer Spehl
Launched: 1999

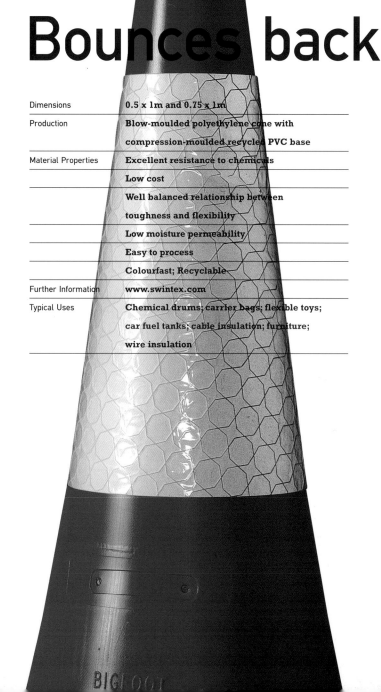

Bounces back

The polyethylene ↘ used for these cones has the same cheap, waxy feeling as Tupperware ↘, and is used for exactly the same reasons: good chemical- and high-impact resistance. From the same polyolefin family of polypropylene ↘, this material is well suited to our aggressive roads.

The traffic cone was first introduced in England in the late 1950s and was used in the construction of the M1 motorway. The higher speeds resulting from the new motorways presented a much greater danger to the maintenance engineers and thus a device was needed to indicate when part of the road was closed off.

Originally traffic cones were a one-piece unit made from rotationally-moulded PVC. In 1985 Swintex launched Bigfoot, a two-piece cone. The base of Bigfoot was made from 100 per cent recycled plastic. The main material for the rest of the cone was polyethylene, which is safer if a car crashes into a cone. It can also withstand temperatures ranging from -24°C to 30°C and will survive and reform its shape after impact with a ten-tonne lorry.

Dimensions	0.5 x 1m and 0.75 x 1m
Production	Blow-moulded polyethylene cone with compression-moulded recycled PVC base
Material Properties	Excellent resistance to chemicals
	Low cost
	Well balanced relationship between toughness and flexibility
	Low moisture permeability
	Easy to process
	Colourfast; Recyclable
Further Information	www.swintex.com
Typical Uses	Chemical drums; carrier bags; flexible toys; car fuel tanks; cable insulation; furniture; wire insulation

Traffic cone
Manufacturer: Swintex
Designer: Steve Parkinson
Launched: 1985

more: Polyethylene 014, 016, 034, 038, 053, 105, 107, 113, 116, 125; Polypropylene 014, 016, 025, 037, 045, 049, 061, 070, 083, 107, 109; Tupperware 125;

016

Dimensions	**81 x 108 x 96cm**
Production	**Rotationally moulded polyethylene**
Material Properties	**Excellent resistance to chemicals**
	Well balanced relationship between stiffness, impact strength and resistance
	Colourfast; Low moisture permeability
	Easy to process; Low cost; Recyclable
Further Information	**www.marc-newson.com, www.rotomoulding.org**
	www.excelsior-roto-mould.co.uk
Typical Uses	**Chemical drums; carrier bags; flexible toys; car fuel tanks; cable insulation; furniture**

Plastic Orgone chair
Manufacturer: Metroplast, France
Designer: Marc Newson
Launched: 1998

'I wanted to produce my own inexpensive version of the Orgone chair. We used rotational moulding so we could make it relatively cheaply and it sold pretty well. Also it gave me a shot at putting something into production again, as I had done in the early days, although that is always more of a pain than you think it will be.'

Marc Newson's emphasis on negative space, which was explored in the original Aluminium Orgone chair, required a manufacturing process that was able to produce hollow forms while, as the designer has stated, using relatively low tooling costs. Due to the nature of rotational moulding the chair comes out from the mould as a completely enclosed shape. To obtain the open ends at the top and bottom of the chair requires a degree of post-formed finishing. This involves cutting the ends of the chair off, which is made easier by having a detail of a thin wall section in the mould at the point where it is cut.

Materials used for rotational moulding are generally low- or medium-density polyethylenes ⭷. Polypropylene ⭷ is used occasionally where high operating temperatures are required in the final product. Polyamides ⭷ are also used in specific situations, but due to the high cost are not a common choice.

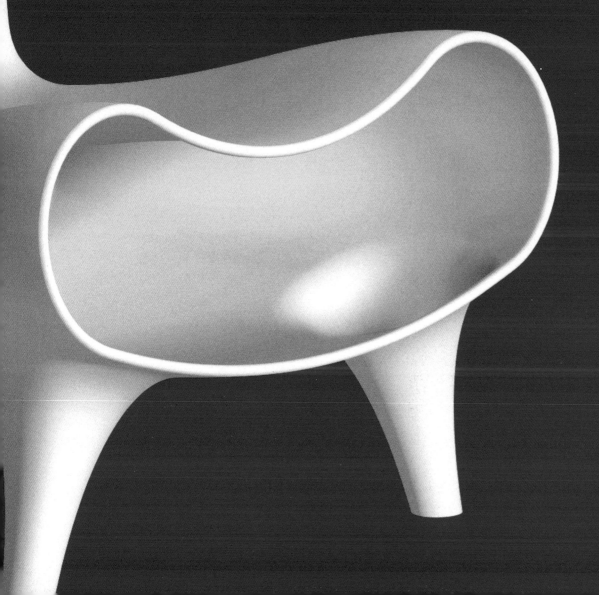

Hollow forms

MAXiM Bench
Designer: Caroline Froment
Launched: 1999

Think of sand

Inspired by the way people on the beach build their rest area in the sand — under their towel — Caroline Froment designed a piece of domestic furniture that recreates the sensation. The main driving force behind this idea was to find a material that would create the desired effect.

The MAXiM Bench feels quite different to a regular beanbag chair. While both are for sitting, the MAXiM Bench offers much more support to the user's form, as it is filled with millions of micro ballons. In the case of a beanbag chair, the tiny Styrofoam (polystyrene ↘) pellets essentially roll on top of each other and by doing so, do not afford the stability and therefore the comfort of the MAXiM Bench. Not only does the bench conform to the contours of the user, it also allows the user to manipulate the cushions to suit his/her needs. Unlike the beanbag chair it will retain its new form until someone decides to modify it.

Dimensions	**Platform: 200 x 100 x 7cm**
	Cushions: 180 x 80 x 5cm
Production	**Filled polyamide ↘ fabric**
Material Properties	**Low density**
	Excellent fluidity
	Non abrasive
	Small (each sphere 0.5mm diameter)
Typical Uses	**In a glass form the micro balloons are used as fillers for various applications to reduce weight. As the micro balloons were designed specifically for the MAXiM there are no other current applications.**

more: Polystyrene 075, 112, 120, 121; Polyamide 016, 069, 091, 093

Dimensions	40 x 15 x 15cm deflated
	73 x 47 x 42cm inflated
Production	Polyester cloth and netting containing
	polyurethane foam. Assembled by the customer
Material Properties	Good chemical resistance
	Economical production of large parts
	Good strength and dimensional stability
	No tooling costs
	Good accuracy of mould surface detail
	Easy to combine with other materials
	Excellent surface finish; Recyclable
Further Information	www.bayer.co.uk, www.via.asso.fr
Typical Uses	Medical equipment; furniture; windows;
	snow boards; decorative mouldings

François Azambourg's ↘ work is based on ongoing research into new materials and technologies and their application into furniture. The chair is specifically for selling by mail order and through hypermarkets and was inspired by the six-packs of bottles available from supermarkets.

Polyurethanes ↘ are important plastics as they can be manufactured in many forms, making them an ideal choice for designers. The Pack chair is fabricated with an internal airtight polyester cloth pouch and a double lining that contains a two-part liquid polyurethane foam. When the user activates a switch the parts are released enabling them to mix together, thereby combusting and filling the form to produce the erect chair. Within a few seconds the form is rigid.

Self-assembly

Pack chair
Designer: François Azambourg
Launched: 2000

more: Azambourg 093; Polyurethane 022, 026, 030, 039, 072, 078, 085, 111, 117, 120

020

Flexible, deformable, exchangeable

Dimensions	**2.5 x 1.51m**
Material Properties	**Low weight compared with steel**
	Good colour retention; UV stability
	Good impact stength; Corrosion resistant
	Good electrical properties; Chemical resistant
	High-temperature performance; Weathers well
	Flame retardant; Moulds quickly
	Very good balance of chemical and mechanical properties
	Low temperature impact strength
	Heat resistance: RTI up to 284°F (140°C)
Further Information	**www.geplastics.com/resins/materials/xenoy.html**
	www.smart.com, www.thesmart.co.uk
Manufacturer	**DMD (Development, Manufacturing, Distribution)**
Typical Uses	**Automotive bumpers and body panels; business equipment housings; mobile phone casings; large structural parts**

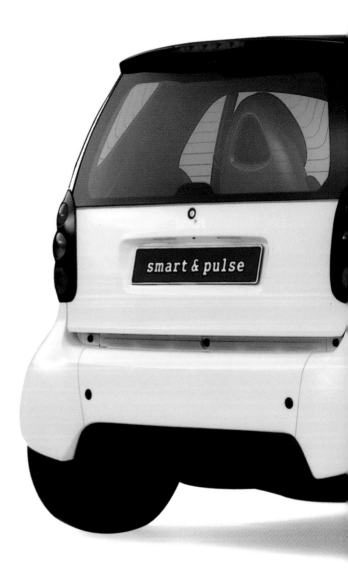

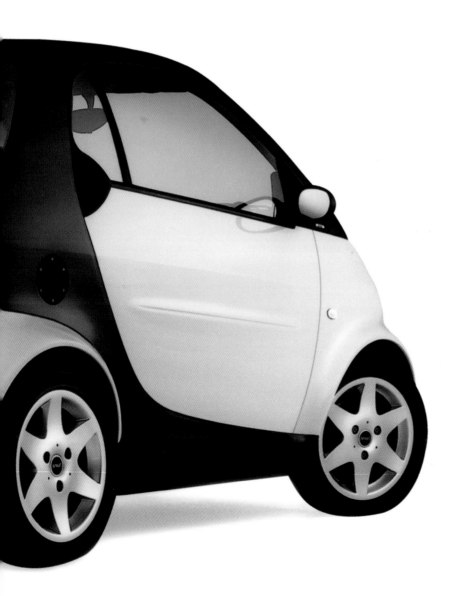

The innovative car panels used for the Smart car come all the way from Smartville in France. They don't need painting, and they will flex so they don't easily dent. Here is a creative solution and antidote to all those keys being run our new cars in the overcrowded metropolis. The panels are made from XENOY®, an engineering resin created by GE Plastics.

The car, jointly developed by Daimler Chrysler and Swatch, won the Grand Award from the Society of Plastics Engineers in the category of 'Most Innovative Use of Plastics'. Conceived in 1994, the Smart car was born out of a desire to push the car beyond its traditional ideas into new functions, and to look at 'the life of materials from factory, through the car's life, to recycling'.

The lightweight alternative to steel means that the nine body panels can be fitted more easily, making production simpler, faster and more cost-effective. Like changing your bed sheets you can change your panels every so often for a new colour; presumably you can mix and match. The panels are naturally corrosion-resistant and a low-impact collision will not dent the car. Each of the nine panels comes in a wide range of colours and can be changed in less than 30 minutes. There is no need to paint or spray.

With a range of colours that include 'phat red' and 'streamgreen' the Smart also reinforces the car as a fashion accessory.

Smart City-Coupé
Daimler Chrysler
Designer: MCC Smart
Launched: 1998

022

Oz
Client: Zanussi
Designer: Roberto Pezzetta
Launched: 1998

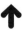

Refrigerators are mostly made from an outside metal panel with a vacuum-moulded internal shell with foam used as an insulatator. Oz breaks the mould of conventional cube fridges that fit neatly in the most convenient space in the kitchen. For this new form to be realised a new material needed to be explored. Polyurethane ↘, one of the most important polymers, is available as thermosets and thermoplastics ↘ with a wide range of properties from open-cell and crushable foams to closed-cell rigid forms. Oz is made from a flame-retardant Bayer-grade polyurethane, Baydur 110, a rigid integral skin foam. The foams are produced by the release of two chemical components into a mould where they expand and fill the mould, solidifying on contact with the walls. Both the internal and external structures are made from the same material making recycling much simpler.

Foam fridge

Dimensions	**142 x 62 x 42cm**
	Door weight: 8.5kg; cabinet weight: 17kg
Production	**Reaction-injection-moulding (RIM)**
Material Properties	**Economical production of large parts**
	Relatively low tooling costs
	Can offer variable wall thicknesses from 3–25mm
	Good strength and dimensional stability
	Good chemical resistance; Easy to paint
	Wide variety of applications and physical properties
	Good accuracy of mould surface detail
	Easy to combine with other materials
	Excellent surface finish; Can be recycled
	Stays rigid even in the lowest temperatures
Further Information	**www.zanussi.com, www.bayer.com**
Typical Uses	**Medical equipment; housing for games and vending machines; furniture; windows; armrests on office furniture; snow boards decorative mouldings; sports equipment; car instrument panels; bumpers; knee pads**

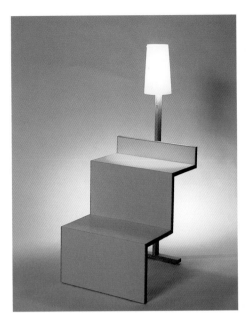
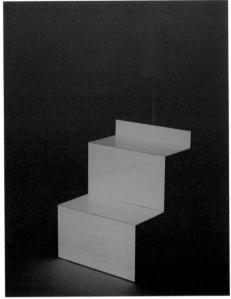

Wee Willie Winkie
Designers: Dominic Jones and
Chris Lefteri
Launched: 1996

Surface as toy

Abet Laminate ↘ is well known as one of the world's leading manufacturers of high-pressure laminates. The company's priority is the design of the surface, and Wee Willie Winkie is a surface that offers an experience.

The main feature of Wee Willie Winkie is the use of Lumifos, a fluorescent laminate that is glued to an MDF structure. The Lumifos surface offers two main functions: the first is to provide a reassuring glow for the child as it sleeps and the second is to provide a surface which the child can play with, creating negative shadows when objects are placed upon it when the light is turned off.

A primary objective of this project was to investigate an alternative creative process that would be an exploration into the design process itself. Its aim was to show how such a process could be used to create new forms, utilise new alternative materials and create new yet relevant scenarios for furniture and products.

Trade Name	Lumifos
Dimensions	50 x 50 x 110cm
Production	Fabricated from plastic fluorescent laminate sheet, MDF and ash timber
Material Properties	Low cost; Versatile production
	Good resistance to chemicals
	High surface hardness and scratch resistance
	Good dimensional stability
	Excellent mechanical strength and stiffness
	Excellent reaction to fire, producing low fumes
	Easy to clean; Good water resistance
	Wide range of finishes, colours and effects
Further Information	www.abet-laminati.it
	www.designlaminates.co.nz/abetlaminati.htm
Typical Uses	Wall cladding; furniture; flooring; work surfaces; door panels

more: Phenolic Resin 043, 066, 118–120, 126; Melamine Resin 042–043; Abet Laminate 042

↑

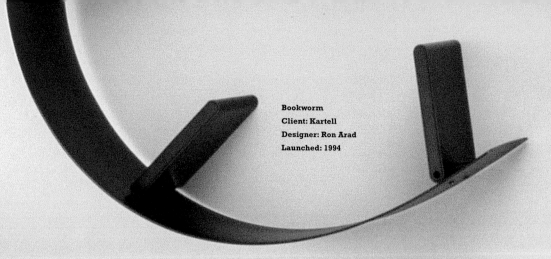

Bookworm
Client: Kartell
Designer: Ron Arad
Launched: 1994

Dimensions	3.2m, 5.2m and 8.2m support 190mm of height
Production	Bulk-dyed PVC
Material Properties	Can be made flexible or stiff; Easy to process
	High abrasion resistance; Flame retardant
	High clarity; Good weather resistance
	Good resistance to chemicals and ageing
Further Information	www.kartell.it, www.ronarad.com
Typical Uses	Cars; electrical engineering; credit cards;
	packaging; shoes; toys; guttering

A product, which started out from a series of experiments with a strip of tempered steel, has become an icon for modern interiors. This translation from steel to PVC ⬎ extends the opportunity for mass production in a form totally sympathetic with the material. The extruded bendy strip allows for different lengths to be sold, enabling the customer to decide the shape the shelving will take on their wall.

The manufacturer Kartell ⬎ has done much to affect the prominence of plastics in the domestic arena. In the early 1950s they began the process that was to revolutionise domestic household items with their range designed by in-house designer Gino Colombini. By the early 1960s polymer technology had progressed enough to enable production of plastic chairs by Richard Sapper and Marco Zanusso.

more: PVC 035, 038–039, 047, 050–051, 058–059, 063, 065, 084, 092, 122–123; Kartell 02

Sold by the metre

Two flat pieces

Polypropylene ↘, the material of the moment, raises its head again in the form of a glossy, bendy chair. This chair was originally created for an Adidas Sport Cafe in France. Like the Bookworm, also by Kartell ↘, it has a soft and sinuous form. However, this is not only a design shouting a great form but a product that reflects new production methods for a chair. It is made from only two main components, an extruded aluminium frame and a polypropylene seat. The seat is produced as an injection-moulded flat sheet which slots into the frame. This process is completed while the frame is still straight. The whole unit is then put into a press which bends the flat shape into a three-dimensional form. The 5mm-thick polypropylene is a flexible material, which provides a strong joint at the point of contact with the frame. It comes in a range of translucent colours.

Dimensions	40 x 78 x 55cm
Production	**Injection-moulded polypropylene and extruded aluminium**
Material Properties	**Good range of translucency and colours**
	Flexible, Excellent live-hinge potential
	Easy and versatile to process
	Excellent resistance to chemicals
	Low density; High heat resistance
	Low water absorption and permeability to water vapour; Recyclable
Further Information	**www.ronarad.com, www.basall.com**
	www.dsm.com/dpp/mepp
	www.dow.com/polypro/index.htm
Typical Uses	**Packaging; domestic accessories; stationery; garden furniture; toothpaste tube lids**

FPE (Fantastic Plastic Elastic)
Client: Kartell
Designer: Ron Arad
Launched: 1996

more: Polypropylene 014–016, 037, 045, 049, 061, 070, 083, 107, 109; Kartell 024, 028–030, 066, 099

Amazonia Vase
Client: fish
Designer: Gaetano Pesce
Launched: 1995

'I believe that death makes us all alike, and that being alive means to be different. The objects that surround us during the short time of our existence help us enjoy that prerogative.' Although he studied architecture and industrial design Gaetano Pesce's work has explored not just the standardisation of mass production but has also the notion of the plastic item being unique. His experimentation with furniture began in the 1960s with work for the Italian furniture producer Cassina. One of the recurrent themes in his work is the exploration of interaction between products and their users. In order to reflect this he has developed a range of products that are deliberately unique.

The originality in his approach comes from his attempt to destroy the idea that plastic products can only be produced by machines where the main criteria are that they are all exactly the same.

Dimensions	353 x 265mm
Production	Poured polyurethane resin
Material Properties	Excellent control; Low tooling cost
	Allows careful control of colour and transparency
	Allows for casting of any thickness
	Perfect clarity; Good adhesive properties
	Versatile forming process
Typical Uses	Furniture; interiors; sculpture; model making

Celebration of chance

The introduction of plastics into cars can be dated back to the first part of this century. Today most cars are made up of at least 30 different types of plastic, generally making up about 30 per cent of all components. The Baja is a lightweight, all-terrain vehicle, one of only two all-plastic cars in production. As such it challenges traditional preconceptions of the use of materials within the automotive industry and demonstrates key advantages over traditional metal alloys.

The Baja comprises both thermoset and thermoplastic ⬎ resins. The body panels are thermoplastic and formed from extruded Korad®, ASA and ABS ⬎ vacuum-formed sheet. A composite chassis tub and roof structure are made of stitch-bonded fibreglass ⬎, vinylester resin and a balsa core. Future Baja vehicles will have the thermoset resin in the chassis and roof structure replaced with a comparable thermoplastic resin in order to satisfy future recycling legislation.

Future ideas

Dimensions	410.5 x 168.3 x 173.4cm
	Curb weight: 1,200kg
Production	**Extruded Korad**
	Vacuum formed
	Stitch-bonded fibreglass
Further Information	**www.plastics-car.com/spotlight/spotlight.htm**
	www.automotivecomposites.com

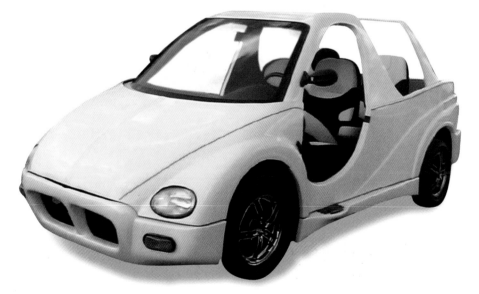

Baja
Client: Brock Vinton
Designer: Michael Van Steenburg,
Automotive Design & Composites Ltd.
Launched: 1998

more: Thermoplastic 022, 029, 071–072, 090, 100–101, 109, 127; ABS 060, 071, 075, 077, 097, 121; Glass Fibre 072, 082, 087, 091, 109, 127

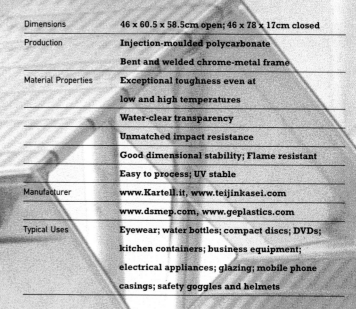

Dimensions	46 x 60.5 x 58.5cm open; 46 x 78 x 17cm closed
Production	Injection-moulded polycarbonate
	Bent and welded chrome-metal frame
Material Properties	Exceptional toughness even at
	low and high temperatures
	Water-clear transparency
	Unmatched impact resistance
	Good dimensional stability; Flame resistant
	Easy to process; UV stable
Manufacturer	www.Kartell.it, www.teijinkasei.com
	www.dsmep.com, www.geplastics.com
Typical Uses	Eyewear; water bottles; compact discs; DVDs;
	kitchen containers; business equipment;
	electrical appliances; glazing; mobile phone
	casings; safety goggles and helmets

Fashionable toughness

Polycarbonate ⬊ is a contemporary material used here in the interpretation of an archetypal object and form. The design makes a direct reference to the kind of wooden ladder you might find under the stairs in your grandmother's house. Instead of using wood it makes use of a modern material which is totally appropriate for this function. Polycarbonate is as tough as polymers come, but is also lightweight and can be produced in a range of colours and finishes.

A relatively young member of the thermoplastic ⬊ family, polycarbonate was, like many plastics, discovered accidentally by the American General Electric Company in the early 1950s. Its main claim to fame as a polymer is as a super-clear, super-tough material, which is often used as a replacement for glass in glazing applications.

The Italian company Kartell ⬊ holds a unique and important role in the field of design. It has been producing domestic objects from plastic since the 1950s. Since then it has pioneered the functional and visual qualities of these materials, creating many well known and classic pieces of furniture and accessories. As is common with Alberto Meda's ⬊ work Upper reflects an understanding of the properties of materials and their application. It is a product that combines the practical, safe, useful and functional qualities of the material with a seductive, modern and fashionable aesthetic.

Upper
Client: Kartell
Designers: Alberto Meda and Paulo Rizzatto
Launched: 2000

more: Polycarbonate 077, 097, 099; Thermoplastic 022, 027, 071–072, 090, 100–101, 109, 127; Kartell 024–025, 030, 066, 098–099; Meda 030

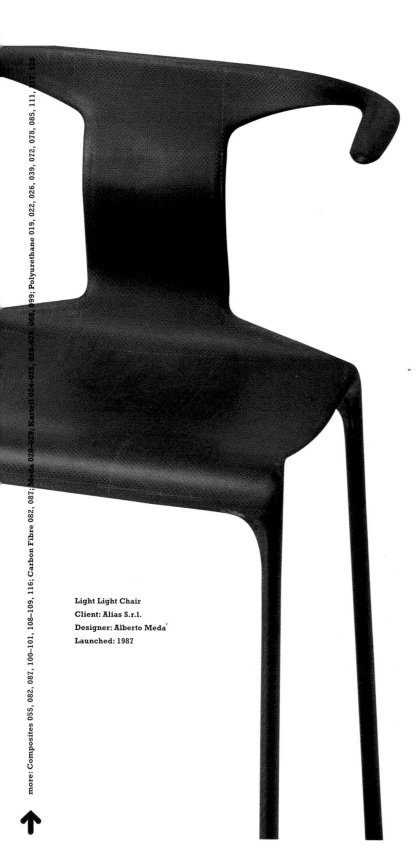

more: Composites 055, 082, 087, 100–101, 108–109, 116; Carbon Fibre 082, 087; Meda 028–029; Kartell 024–025, 028–028, 066, 099; Polyurethane 019, 022, 026, 039, 072, 078, 085, 111, 117, 120

Light Light Chair
Client: Alias S.r.l.
Designer: Alberto Meda
Launched: 1987

Dimensions	743 x 383 x 495mm
Production	Moulded carbon fibre in an epoxy-resin matrix and polyurethane foam
Material Properties	Great strength to weight ratio; Easy to customise
	Extremely durable; Distinctive surface finish
	Available in a range of colours
	Good chemical resistance; Non-corrosive
	Neutral to aggressive environments
	Good temperature range; Non-conductive
Further Information	www.globalcomposites.com, www.hexcel.com
	www.carb.com, www.composites.com
Typical Uses	Aeronautical and space industry; boats; automobiles; sports equipment; civil engineering; rail transport; architecture

Weightless

There are many uses and applications for the unique physical properties of composites ↘ and in particular carbon fibre ↘. However, the refinement of form and its relationship to the structure and function makes this chair a beautiful example of this material.

Unlike most designers Alberto Meda ↘ began his career as an engineer in 1970 as technical director of Kartell ↘, one of the most important manufacturers of domestic objects in plastic. His Light Light chair typifies his search for new materials in furniture as does his Lola light for Luceplan, also made of a combination of carbon fibre and rubber.

With Light Light Meda wanted to reduce the weight of the chair to a minimum and to emphasise the high strength to weight ratio of the carbon fibre — the chair weighs a mere 1kg. The core of the seat and backrest is made from a rigid polyurethane ↘ honeycomb structure concealed by the layering of the carbon fibre over the top, which creates a unique surface pattern.

Miss Blanche
Client: Kurumata Design Office
Designer: Shiro Kurumata
Launched: 1988

Dimensions	**905 x 625 x 600mm**
Production	**Cast acrylic resin**
	Plastic epoxy-coated aluminium tubes
Material Properties	**Low tooling costs**
	Allows careful control of colour and transparency
	Allows for casting of any thickness
	Excellent optical clarity
	Good adhesion
	Easy to colour
	Outstanding UV resistance
	Versatile forming process
Further Information	**www.ineosacrylics.com**
Typical Uses	**Ornamental paperweights; furniture;**
	interiors; sculpture; model making

Shiro Kurumata has produced many designs where the dominant feature is the element of surprise and the experimental use of materials. Designed for the Kagu Tokyo Designers Week exhibition in 1988 and inspired by a dress worn by Blanche Dubois in the film 'A Streetcar Named Desire', this chair is made largely by hand. This allows for ultimate control over the design and the aesthetic qualities of the resin. The tooling costs of making the mould are relatively low.

The main body is formed by dropping imitation roses into a mould filled with liquid acrylic resin, which can be done at room temperature. The main technical problem with casting such intricate shapes is the suctioning off of any air bubbles which form around the folds of the petals which are held in place by tweezers. The chair is formed of three separate elements – seat, back, armrests – and once these have cured they can be glued together allowing for complete transparency.

Liquid transparency

033 Flat

Plastic money

Mylar® and Melinex® are two of the most common polyester films. They can be used for a vast range of applications from video and printed circuit boards to laminating ripstop Nylon ⬎ for Richard Branson to use on his hot air balloons. For the purpose of the balloons 12-micron-thick Melinex® was able to remain flexible at temperatures of -70°C while withstanding the heat from the burners. In the food packaging industry it is used as a lid for ready meals which are kept in freezers and are immediately put in an oven, proving that it is dimensionally stable. It can also take printing ⬎ very well, another advantage for its use in packaging. Melinex® as a printed film for reprographics springs back to a flat sheet even when tightly rolled up and is heat- and chemical resistant.

Dimensions	**Available from 12–350 microns**
Production	**Printed extruded sheet**
Material Properties	**Good temperature resistance; Good optical clarity**
	Excellent print capabilities; Recyclable
	Rigid; Good resistance to chemicals
	Excellent strength compared to cellulose acetate ⬎ film
	Good dimensional stability; Non-toxic
Further Information	**www.dupontteijinfilms.com**
Typical Uses	**Food wrapping; credit cards; labels; dart fins; substrate for printed circuit boards; x-ray films; motor insulation; wind surfing sails; lids on yoghurt pots; protective window film**

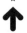

Everybody knows that the best thing about cling film is its ability to stick to itself — that satisfying self-supporting grip that happens when you wrap it over your bowl and it clings. If it were not such an everyday event it might appear quite special, almost magical. Great designers are able to see these everyday common events and transform them into new functions.

With Thomas Heatherwick's exhibition for the Glasgow Festival of Architecture and Design there is no traditional use of big construction. It just takes the idea of using an existing material and applying it on a unique scale. The gallery space of almost 600 square metres has a high ceiling supported by cast-iron columns, which support 75 miles of the industrial version of cling film, stretch wrap. The PVC ↘ structure achieves three functions: it suspends, wraps and separates the exhibits. The lighting is achieved through housing in 'basic ducting units', contained within the PVC structure.

Trade Name	**Lastia**®
Production	**Wrapped extruded PVC sheet**
Material Properties	**Extremely pliable; Clear**
	Adheres to any smooth, dry, glossy surface or itself without additional adhesive
	Offers cost-effective protection of products
	Can be modified to allow for printing
	Range of colours available, including metallic
	Available in a range of gauges and finishes
	Can stretch to 150% of its original shape
	Affordable and easy to use
	Available with UV stabiliser for outdoor use
	Easily protects uneven shapes
Further Information	**www.baco.co.uk**
Typical Uses	**Industrial packaging; food wrap**

Strong, stretchy, transparent

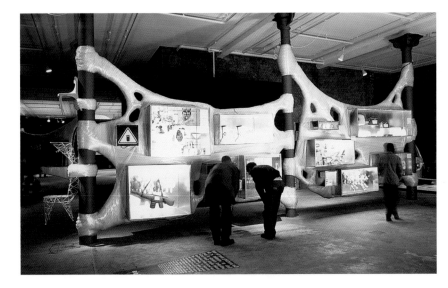

Identity Crisis
Client: Glasgow Festival of
Architecture and Design
Designer:
Thomas Heatherwick Studio
Launched: 1999

more: PVC 024, 038–039, 047, 050–051, 058–059, 063, 065, 084, 092, 122–123

Dimensions	**10 x 30 x 40cm**
Production	**Thermoformed polypropylene sheet**
Material Properties	**Good range of translucency and colours**
	Low density; High heat resistance
	Good balance between toughness, stiffness and hardness
	Easy and versatile to process
	Excellent resistance to chemicals
	Excellent live-hinge potential
	Low water absorption and permeability to water vapour; Recyclable
	Low coefficient of friction; Relatively low cost
Further Information	**www.vtgdoeflex.co.uk**
Typical Uses	**Furniture; packaging; lighting; food packaging; table mats; point of sale; folders; folio cases**

Low-cost tooling for batch production

Design is not always restricted to the creation of beautiful forms and functions but often seeks to solve the problems of high unit and tooling costs by avoiding large-scale production runs. The brief asked for a product that had to be manufactured by mass-production methods, with mass-production unit costs, but without mass-production tooling investment and quantities. Initially the client wanted to use melamine ↘ as the material for a take-away lunch box, but this was not the most economical option. The alternative, die-cut polypropylene ↘, was being used in every sphere of product design from packaging, lighting, domestic accessories, but its use had not been fully explored through the process of thermoforming.

The box is made from sheets of 1.2mm food-grade thermoformed polypropylene. The thin sheet gained a rigid structure from the curved surfaces in its form and the minimum 3mm lip which runs around the edge of each unit. The material was also ideal because it is recyclable, and the potential for thermoforming with the material meant that tooling costs and unit prices were low in relation to the production volumes.

Bento Box
Mash & Air, London,
Manchester, U.K.
Designers: Toni Papaloizou,
Chris Lefteri
Launched: 1998

more: Melamine 042–043, 066, 120, 124; Polypropylene Sheet 045, 049, 070

Dimensions	**6mm to 400mm diameter tubes**
	Also available in sheet
Production	**Extruded or woven**
Material Properties	**Good UV resistance; Strong visual appeal**
	Similar to elastomeric materials in flexibility
	Good resistance to chemicals; Easy to colour
	Food grade; Can fit any form; Formable
	Maintains physical properties
	at low temperatures
	Contents are exposed but still protected
	Large range of sizes; Good strength to weight ratio
Further Information	**www.netlon.co.uk**
Typical Uses	**Packaging; exfoliating scrubs; bra supports; cars**

This meshy material comes in a wide spectrum of colours and sizes from finger-skinny tubes to super-wide tubes, from soft and flexible to hard, rigid versions. They can be either extruded (as in Duty Free bottles) or woven (used to package oranges). EVA is particularly suited for protective packaging because of its natural resistance to chemicals. It can be compared to polyethylene ↘ and plasticised PVC ↘. Minimal use of raw material makes it a good economical and environmental alternative to board and moulded plastic. It can also be thermoformed giving a whole range of other applications. The open 'weave' in the extruded products means that other materials can be formed through and round it as in reinforcement for bras.

Flexible and stretchy

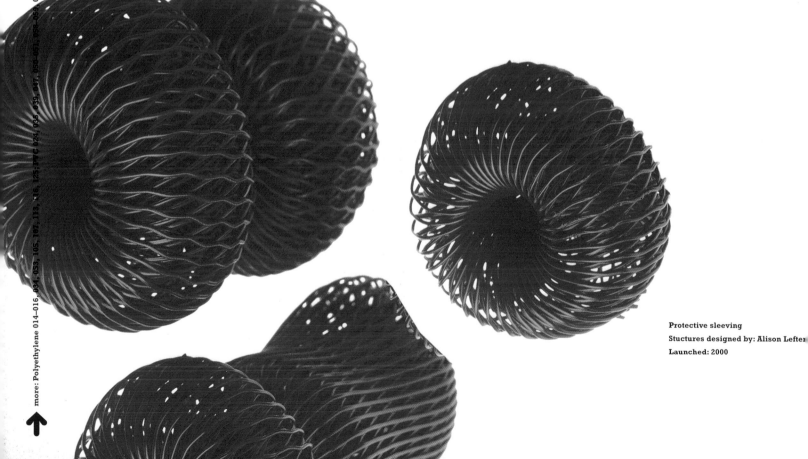

Protective sleeving
Stuctures designed by: Alison Lefter
Launched: 2000

↑ more: Polyethylene 014–016, 034, 053, 105, 107, 113, 116, 125; PVC 024, 039, 047, 055–057, 058–059, 063, 065, 084, 092, 122–123

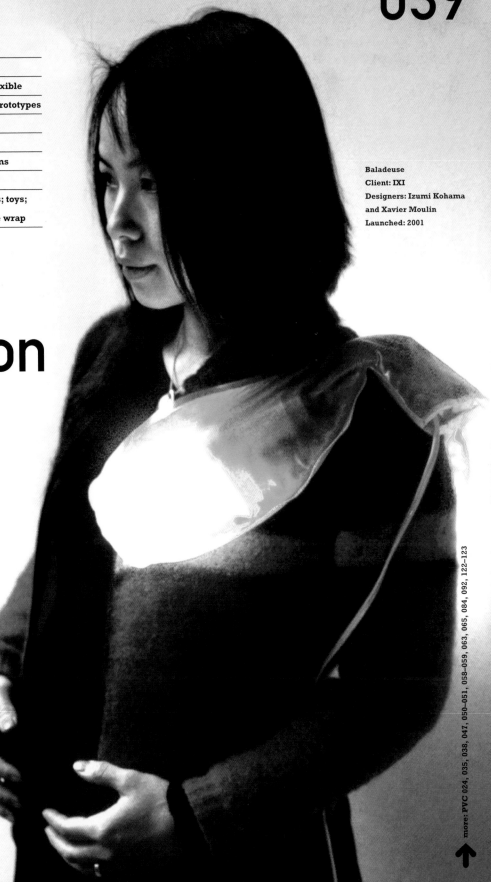

Dimensions	60 x 303mm
Production	**Ultrasonically welded PVC**
Material Properties	**Easy to process with low-cost tooling; Flexible**
	Easy to colour; Easy for making one-off prototypes
	Good transparency; Good UV properties
	Good strength at low temperatures
	Versatile material available in many forms
Further Information	**www.ixilab.com, www.vinylinfo.org**
Typical Uses	**Cable insulation; condoms; sewage pipes; toys;**
	wallpaper; raincoats; table cloths; bubble wrap

Baladeuse
Client: IXI
Designers: Izumi Kohama
and Xavier Moulin
Launched: 2001

New form, new function

This is an intriguing idea — a lamp that combines liquid with light. The use of the soft PVC sheet filled with a gel not only gives new tactile qualities to the lamp, but also provides new approaches to its function and location.

PVC ↘ is one of the best known materials; it is synonymous with the word plastic itself. It can be processed by virtually all the major plastics processing techniques and is one of the easiest to adapt to different requirements. It is like pasta waiting for its sauce.

IXI have described themselves as a 'virtual design agency'. Baladeuse is part of a project called 'Interspace'; a collection of objects designed to 'surf the chaos' and adapt to what already exists in the home. The light has no form when it lies flat on the floor, but takes the shape of the object that supports it — you can even wear it. The lamp source is a standard compact fluorescent bulb that is surrounded by a sticky polyurethane gel, and then wrapped in an ultrasonically welded PVC skin.

more: PVC 024, 035, 038, 047, 050–051, 058–059, 063, 065, 084, 092, 122–123

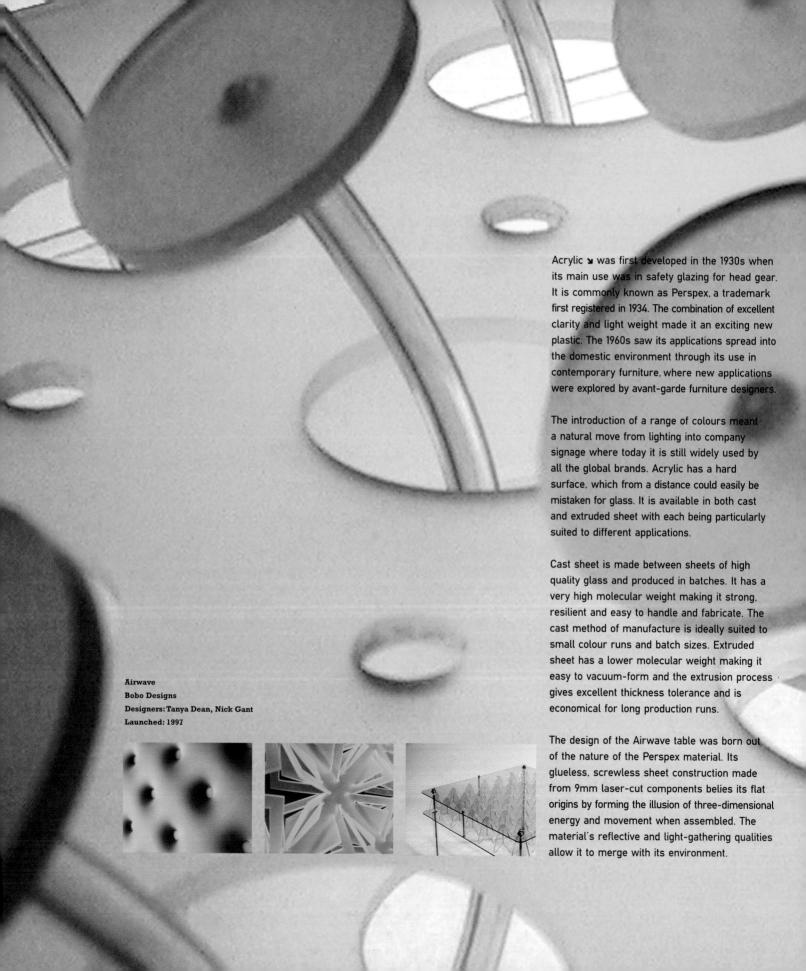

Acrylic ↘ was first developed in the 1930s when its main use was in safety glazing for head gear. It is commonly known as Perspex, a trademark first registered in 1934. The combination of excellent clarity and light weight made it an exciting new plastic. The 1960s saw its applications spread into the domestic environment through its use in contemporary furniture, where new applications were explored by avant-garde furniture designers.

The introduction of a range of colours meant a natural move from lighting into company signage where today it is still widely used by all the global brands. Acrylic has a hard surface, which from a distance could easily be mistaken for glass. It is available in both cast and extruded sheet with each being particularly suited to different applications.

Cast sheet is made between sheets of high quality glass and produced in batches. It has a very high molecular weight making it strong, resilient and easy to handle and fabricate. The cast method of manufacture is ideally suited to small colour runs and batch sizes. Extruded sheet has a lower molecular weight making it easy to vacuum-form and the extrusion process gives excellent thickness tolerance and is economical for long production runs.

The design of the Airwave table was born out of the nature of the Perspex material. Its glueless, screwless sheet construction made from 9mm laser-cut components belies its flat origins by forming the illusion of three-dimensional energy and movement when assembled. The material's reflective and light-gathering qualities allow it to merge with its environment.

Airwave
Bobo Designs
Designers: Tanya Dean, Nick Gant
Launched: 1997

Transparency

Dimensions	**100 x 100 x 45cm**
Production	**Cast acrylic sheet**
Material Properties	**High melting point; Low-cost tooling**
	Easy and versatile to fabricate and process
	A wide range of transparent, translucent, and opaque colours and surface finishes
	Laser cutting allows for production of 1 or 100 pieces
	Excellent resistance to chemicals and weathering
	High print adhesion; Fully recyclable
	Excellent optical clarity
	Exceptional colour creation and colour matching
	Outstanding surface hardness and durability
	An extensive range of sheet sizes and thicknesses
Further Information	**www.ineosacrylic.com, www.perspex.co.uk**
	www.bobodesign.co.uk, www.lucite.com
Typical Uses	**Display; point of sale; retail signage; interiors; furniture; lighting; glazing**

more: Acrylic 031, 055, 088

↑

Abet Laminate ↘ was founded in 1957 in Bra,
Italy, and has since then been at the forefront
of innovation with the production of various
laminates ↘ including Diafos, introduced in 1987,
the first transparent laminate. It has worked
with some of the most prominent designers of
the 20th century including Memphis and Studio
Alchimia, and is known for its experimentation
with surface. Straticolour is a unique product
made by Abet Laminate, which explores the
function and visual qualities of edging.

With standard-thickness laminate sheet there
are two layers of material. The core is made
from layers of paper, which are impregnated
with aminoplastic resins, and laid on to that is a
surface made of decorative papers impregnated
with melamine resins ↘. In Straticolour Abet
has introduced the decorative layer as the core
of the material. The edge can be polished giving
a unique edging detail.

The edge

Dimensions	Standard-size sheets 122 x 305cm
Material Properties	High abrasion resistance; High impact resistance
	Excellent moisture resistance; Easily glued
	Good water and vapour resistance
	Good resistance to chemicals; Easy to clean
	Good dimensional stability; Hard wearing
	Highly decorative finish on edges
	Economical compared to other solid surfacing materials
Manufacturer	Abet Laminate
Further Information	www.abet-laminati.it
Typical Uses	Office furniture; interior and exterior paneling; flooring; street furniture; worktops

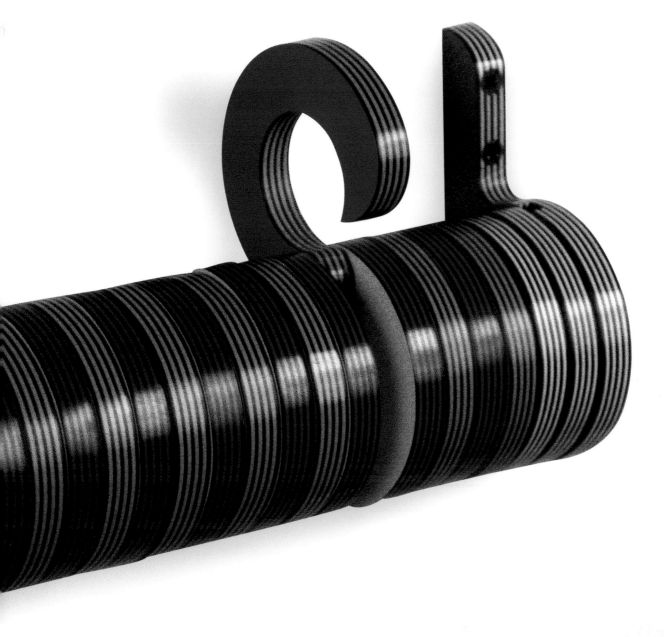

more: Abet Laminate 023, 042; Laminate 023, 066, 118, 120, 124, 126; Melamine Resin 023

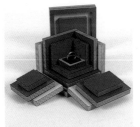

Pianomo (centre)
Designer: Shun Ishikawa
Ringo (right)
Designer: Matthew Jackson
W Table (far right)
Designer: Adrian Tan

Luton Sixth Form College
Learning Resources Centre

Works like paper

Dimensions	**30 x 30 x 10mm; 10 x 43 x 129mm; 1450 x 2000mm**
Production sheet	**Die-cut polypropylene**
Material Properties	**Can be heat-welded, ultrasonically welded, riveted, stitched and embossed**
	Easy to process; Excellent resistance to chemicals
	Excellent live-hinge potential; Recyclable
	Low water absorption and permeability to water vapour
	Manual assembly process; High print adhesion
	Virtually tear resistant; Low density; Cheap tooling
Further Information	**www.vtsdoeflex.co.uk**
Typical Uses	**Furniture; packaging**

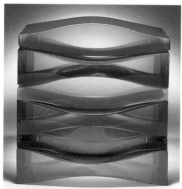

Tummy and Bow Bags (left)
Spine Knapsack (centre)
Issey Miyake, Japan
Designer: Karim Rashid
Launched:1997
Placemats (right)
Designer: Sebastian Bergne

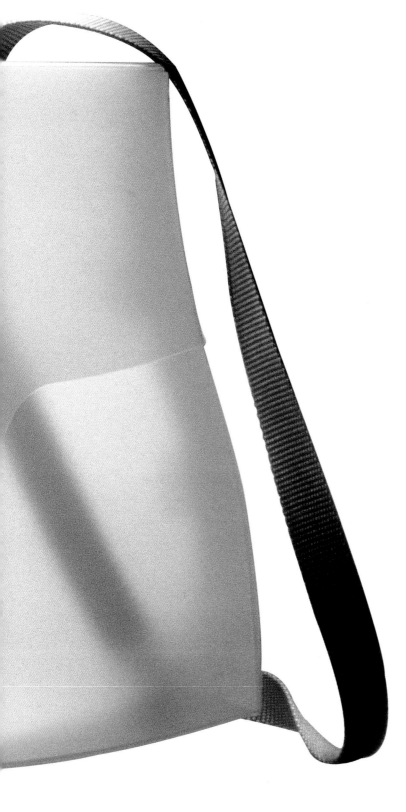

Polypropylene ⩘ is not a new material. It has been around virtually anonymously in the public's knowledge since the 1950s and has since proved itself as the material for the 1990s. The German manufacturer Authentics ⩘ has had a large impact on the use of moulded polypropylene but another area where it is being widely used is as a flat-sheet material. As sheet it has provided the opportunity for plastic products to be made from paper processes like folding, cutting and creasing with the result that products need minimal investment in tooling. As a result it has become extensively used in all forms of packaging. It needs no tooling to make prototypes, just a sharp knife, a ruler and a cutting mat.

The Spine Knapsack is one of a series of bags designed exclusively for the Issey Miyake boutiques in Japan. These sheets of recyclable, extruded, transparent polypropylene have seams (or living hinges) that are easy to flatten down to their two-dimensional shape. The interior has a co-extrusion of fluorescent polypropylene that is reversible, which changes the interior glow of the bag from yellow to orange. The translucent latch is injection-moulded polypropylene.

The Tummy and Bow bags, also designed for Issey Miyake, are both created from the same pattern. The garment is placed in the centre and the bag is folded and snapped together to create a very rigid and strong package. They stack in three different configurations for store display.

more: Polypropylene Sheet 037, 049, 070; Authentics 14, 70–71

Tailoring in plastic

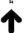

Colourscape
Client: Colourscape Music Festival
Artist: Peter Jones
First produced in 1971

Dimensions	From 35 x 40m to 50 x 60m; height 5m
Production	High frequency welding
Material Properties	Easy to process with low-cost tooling
	Flexible; Easy to colour
	Good transparency; Good UV properties
	Easy for making one-off prototypes
Further Information	Peter Jones telephone: 01970 871709
	Colourscape telephone: 020 8763 9298
	www.colourscapefest.in2home.co.uk
	www.oxyvinyls.com
Typical Uses	Cable insulating sheaths; sewage pipes; table cloths; handle grips for bikes; toys; packaging; wallpaper

Peter Jones, an artist who originally used paint as his medium, has moved to plastic to explore space and colour in a larger context. His resulting work has been described in many ways — as sculpture, architecture and even archisculpture.

Each inflatable ◢ structure is composed of a number of primary coloured, translucent PVC ◢ panels that are positioned to overlap each other and form different colour variations and combinations. As visitors walk through the installation the colours appear to change as one panel overlaps another. So strong is this impression that visitors often mistake the effect as being achieved through coloured lights.

In its pure form PVC is very strong and due to the transportation and storage of the structures this thin 0.25mm material is ideal. The early structures were made exclusively by hand, but the larger scale of the more recent structures have needed to incorporate elements of factory production.

Dimensions	**630 x 1430mm; 6–8mm thickness**
Production	**Finished sheets can be laser cut, routed, water jetted and processed by most conventional flat-sheet processing**
Material Properties	**Low heat and thermal conductivity: 'warm feel'**
	Distinctive visual appearance; Gloss finish
	Good range of visual effects; Anti-static
	Good electrical insulation properties
	Self-shining; Excellent impact resistance
	Good transparency; Versatile production
	Made from renewable source
Further Information	**www.mazzucchelli1849.it/newsite/inglese /comphist.htm**
Typical Uses	**Safety and sports goggles; frames for sun glasses; jewellery; watch straps; rain coats; lighting; bags**

Hand-made

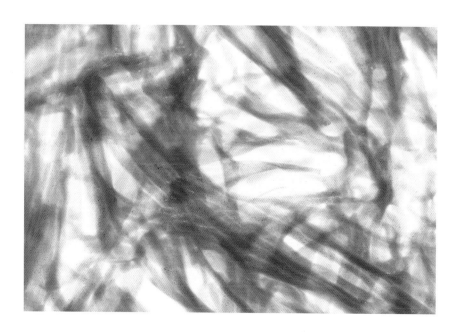

Processing Sicoblock (left)
Flat-sheet material (far left)
Manufacturer: Acordis

Swirling clouds of colour inside a warm slice of processed cotton. This distinctive quality is what makes cellulose acetate ↘ unique. The process, used to make the flat sheets, has been used since the founding of Mazzucchelli in 1849.

You will need:
• A large amount of cotton plant or wood pulp
• Natural minerals of artificial dye (for colour)
• A good quantity of acetate
• A sharp knife
• A large sealable container

What to do:
First pick the cotton and through the process of purification produce cellulose. If you don't have cotton you can use wood pulp. Once you have obtained the cellulose, mix it together with acetate and add your own choice of natural mineral or artificial colour – the choice of colour is obviously up to you. Add plasticisers and light and heat stabilisers as required. Pass this mixture through rollers to obtain a flat sheet, known as the 'hyde'. The hyde should be a soft, floppy sheet which resembles a leather hyde. Then with your knife cut the hyde into a number of shapes. Carefully lay your cut-out shapes in the large container. Now apply heat and pressure to the container and bury underground. When your mixture has reached the consistency of a thick jelly it is ready to be cut from the block into thin slices. Hang these slices out to dry.

more: Cellulose Acetate 034, 061, 067

↑

Lighting in a box

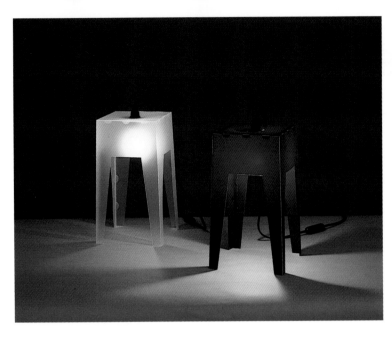

Ultra Luz range
Client: Proto Design
Designers: Marco Sousa Santos,
Pedro S. Dias
Launched: 1995

Dimensions	**Various**
Production	**Die-cut polypropylene sheet**
Material Properties	**Non flammable; Washable; Unbreakable**
	Can be heat welded, ultrasonically welded, riveted, stitched, and embossed
	Excellent resistance to chemicals
	Easy and versatile to process
	Excellent live-hinge potential; High print adhesion
	Low water absorption and permeability to water vapour; Manual assembly process
	Recyclable; Very cheap tooling
Further Information	**www.vtsdoeflex.co.uk**
Typical Uses	**Furniture; packaging; lighting; stationery; table mats; point of sale**

The Ultra Luz range is the result of a brief to investigate the potential for a self-assembly ⬎ light which only uses flat polypropylene sheet ⬎ and standard light fixtures. The restrictions placed on this simple and inexpensive production process forced new approaches to the aesthetics and function of lighting.

Polypropylene sheet like ultrasonically welded PVC sheet ⬎ challenges the misconception of designed products as being only for the people who can afford them. It offers a range of colours and printing processes that can be used to give this material endless potential to create new forms for everyday products. The collection consists of a range of 19 models of pendant and table lights which all self-assemble. To enforce the original state of the material the lamps are sold in a pizza-box package and are assembled by the user.

more: Self-assembly 093, 121; Polypropylene Sheet 037, 045, 070; PVC Sheet 035, 039, 050-051, 059

Cheap tooling

Production	Ultrsonically-welded PVC sheet with satin finish
Material Properties	Easy to process with low-cost tooling
	Flexible and versatile
	Easy to colour; Good UV properties
	Easy for making one-off prototypes
	Tough even at low temperatures
	Good transparency
Further Information	www.inflate.co.uk, www.vinylinfo.org
Typical Uses	Chemical drums; carrier bags; flexible toys; car fuel tanks; cable insulation; furniture

The uses of PVC ⬎ within manufacturing are extensive, but Inflate, established in 1995, has done more to create a fun, dynamic expression of the accessible, cheap qualities of this sheet material and bring it to the forefront of people's attention. As recent design graduates, their use of inflatables solved the problem of how to mass-produce in plastics with low-cost tooling and investment. The value of their diverse range of inflatable products comes from the fact that they create original products by restricting the manufacture and production to one material and one process (ultrasonic welding).

Dip moulding was a natural evolution of the inflatable products. It fulfilled the criteria of bright colours and cheap, flexible production. Inflate have established themselves within contemporary design as a company who have taken the low-technology principles of PVC sheet ⬎ and until then, low-value products, and have through design found new objects with high-value appeal, while still using a very basic process.

Their achievement reverses the perception of plastic as only a high investment material for mass production, with its use here for a 'hands on', almost craft-like process ⬎ with minimal tooling. Products can be just as easily produced as 'one-offs' or in their thousands.

1. Stencil for prototype

2. Transfer of template

3. Welding machine

Table light
Client: Inflate
Designer: Nick Crosbie
Launched: 1995

more: PVC 024, 035, 038–039, 047, 058–059, 063, 065, 084, 092, 122–123; PVC Sheet 035, 039, 049, 059; Craft Process 055, 063

Material Properties	Good strength and tear resistance
	Allows for continuous folding and flexing
	Keeps properties in wide temperature range
	Unaffected by most chemicals
	Non-toxic; Chemically inert; Weather resistant
	Conforms to International Maritime
	Dangerous Goods labelling code (BS 5609)
	Approved for contact with foodstuffs and cosmetics
	Conforms to draft EC directives on packaging waste
	and German legislation on compatible labelling
Manufacturer	www.duponttyvek.com
Typical Uses	Security envelopes; protective clothing;
	speciality packaging; roofing membranes;
	tags and labels; banners; maps; reinforcing; kites

Paper thin, super strong

fold 4

fold 5

fold 6

Tyvek® is the DuPont trade name for a range of high-density polyethylene sheet materials. The sheet is formed by spinning continuous strands of very fine interconnected fibres, which are then bonded together by the application of heat and pressure.

Different weights are available offering varying qualities from fairly stiff to fabric-like. It can be stapled, sewn, tied or glued ↘. When a hole is punched
it doesn't weaken the material and you can even print on it using your computer printer ↘ although it is notoriously difficult to print. One of the uses for Tyvek® is for yachting maps which are unaffected by salt water to the point of being able to withstand three months submerged.

The Hussein Chalayan dress was designed with the intention of igniting the debate about letter writing, and could be regarded as clothing, art or a letter. It is deliberately contructed to fold and roll in on itself. The size of the garment can be adjusted to fit through use of perforations and adhesive labels.

Airmail dress
Client: Hussein Chalayan
Designers: Rebecca and Mike

By Airmail
Par Avion

more: Polyethylene 014-016, 034, 038, 105, 107, 113, 116, 125; Glue 063, 085, 121, 123; Printing 034, 041, 044, 049, 088, 117, 131

Dimensions	Sheet size 3680 x 760 x 13mm
Production	Heat bending
Material Properties	Malleable when heated; High impact resistance
	Strong and hard; Scratches easy to remove
	Enables versatile production methods
	Highly workable; Hygienic; Stain resistant
	Comes in variety of thicknesses as sheet
	Good colour-fade resistance
	Excellent resistance to chemicals
Further Information	www.corian.com, www.dupont.com
Typical Uses	Furniture; work surfaces; lighting; retail;
	intelligent desktops/worktops; transportation;
	wall cladding; shelving

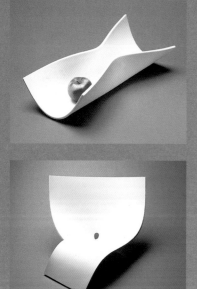

Designer: Gitta Gschwendtner
and Fiona Davidson
Client: DuPont Corian©
Launched: 2000

Its traditional use as a kitchen work surface is ideal as it means that any scratches and dents in the surface can easily be sanded out. Its non-porus surface means it is also hygienic. But Corian® has come out of the bathroom and kitchen and on to the design scene. Fiona Davidson and Gitta Gschwendtner have applied a craft-like process ↘ allowing it to display its unique qualities.

Corian® is the trade name for a composite of natural minerals, pure acrylic ↘ polymer and pigments. This homogeneous material was launched 30 years ago as a kitchen worktop material and can be cast, sanded, sandblasted, thermoformed, vacuum-moulded and fabricated into a vast range of shapes and forms. It is inherently strong, durable and highly workable. It has a hard marble-like surface but is warmer, with a silky-smooth natural finish. Scratches and blemishes can be sanded away and the surface polished. DuPont offer it in a range of 93 colours and textures including translucent and light-reflecting finishes. The fabrication of sheets can be done with minimal tooling, and sheets can be joined by a special two-part adhesive to create an almost seamless joint.

Shapes and recesses can be carved or moulded into the surface of the material allowing for new functions in standard desktops. These products rely on the material being heated, restricting the movement of Corian® while it cools through the use of basic wooden jigs and clamps. This simplified manufacturing philosophy results in a range of objects that unashamedly exhibit their sheet material origins.

more: Craft Process 051, 063; Acrylic 031, 040–041, 088

Out of the kitchen

057 Main courses

Heat resistant, flexible

Dimensions	**110 x 210mm**
Production	**Dip-moulded, heat-resistant PVC; 25-watt lamp**
Material Properties	**Excellent outdoor properties**
	Low-cost tooling; Simple processing
	Soft; Forms can have undercuts
	Easy for making one-off prototypes
	Good tactile qualities; Cheap material
	Excellent outdoor properties
Further Information	**www.droog.nl, www.vinylinfo.org**
	www.dmd-products.com
Typical Uses	**Handle-bar grips**

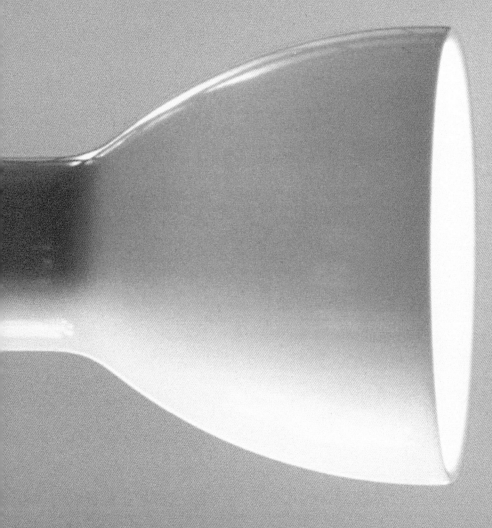

Since their establishment in 1994 Droog Design in the Netherlands has challenged the notion of various object typologies and experimented with changing the preconception of the function of materials. They are not content to merely provide new forms, but seek to create products with new functions and meanings. They reconcile the use of plastic as a high-volume material with freethinking and experimentation, which can result in the production of ten or 1000 units of a design.

PVC � is an extremely versatile polymer. In its pure state it is a rigid material – it is through the addition of plasticisers that it can become soft as in PVC sheet ⬦ which was used for the Soft Lamp. Arian Brekveld's light uses a very common dip-moulding process to take PVC to new territory. The heat-resistant PVC has the appearance of glass with its translucent quality, allowing enough light through to provide a soft glow when the light is on and also provide a new tactile experience. As Brekveld explains, 'I tried to give the lamp the most subdued form I could. I like the way the cord almost melts into the shade.'

Soft Lamp
Client: DMD
Designer: Arian Brekveld
Launched: 1995

more: PVC 024, 035, 038–039, 047, 050–051, 063, 065, 084, 092, 122–123; PVC Sheet 035, 039, 049–051

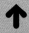

060

Metal to plastic

Dimensions	**200 x 60 x 50mm**
Production	**Injection-moulded ABS; injection-moulded TPO**
Material Properties	**Low cost; Versatile production**
	Good resistance to chemicals
	High surface hardness and scratch resistance
	Good dimensional stability; High impact strength
	Excellent mechanical strength and stiffness
Further Information	**www.acco.com, www.geplastics.com**
Typical Uses	**Consumer electronics; toys; white goods;**
	automotive consoles; door panels; exterior grilles

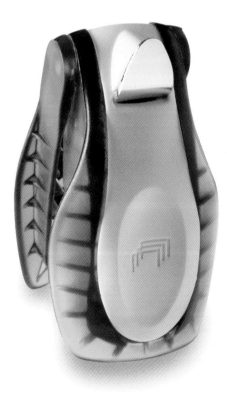

Acco wished to replace its high-volume, cost-effective stapler with an updated and improved design while not increasing the cost. Typically plastic staplers do not perform as well as their metal counterparts. Through thorough analysis and mindful engineering the design team was able to create an ABS ⬎ stapler that fails less than one per cent of the time in extensive performance and testing. This made it potentially one of the best Swingline staplers ever, an amazing claim considering it is a 'cheap' plastic stapler and the fact that the Swingline brand has historically been known for its robust, reliable and enduring products. The ribs not only contribute visually to the design, but also provide much needed rigidity in the cap helping it to achieve its superior performance. The product can be assembled and disassembled using no tools and can be easily separated for recycling.

**Swingline Desktop/Swingline
Worx '99 Mini Staplers
Client: Acco
Designer: Scott Wilson
Launched: 1998**

more: ABS 027, 071, 075, 077, 097, 121

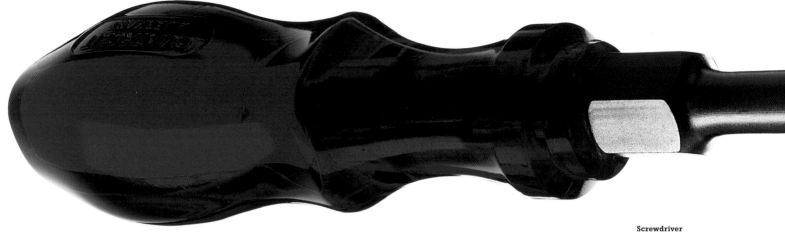

Screwdriver
Acordis

Warm

Dimensions	**Various**
Production	**Injection moulded**
Material Properties	**Low heat and thermally conductive**
	Flexible production; Good range of visual effects
	Excellent flow properties; Excellent gloss finish
	Good electrical insulation properties
	Anti-static; Self shining; Good transparency
	Excellent impact resistance
	Distinctive visual appearance
	Made from renewable source
Further Information	**Acordis Ltd, Derby, UK**
Typical Uses	**Tool handles; hair clips; toys; goggles and visors;**
	spectacle frames; toothbrushes; cutlery handles;
	combs; photographic film

Warm to the touch, perspiration tolerant and self-shining, cellulose acetate ↘ with its brightly coloured boiled-sweet transparency is an old polymer. Developed at the beginning of the century it is older even than Bakelite ↘. One of the most easily recognisable polymers due to its usual marbled effect it is seen in such items as tool handles, spectacle frames and hair clips. For its use in hand tools it provides a good compromise between excellent impact resistance and good tactile quality. Other materials like polypropylene ↘ have better impact resistance but would probably feel more slippery. The self-shining element comes from the soft nature of the material, and light scratches on its surface can be polished away. Made partly from cotton and wood (cellulose), it can be injection moulded, rotationally moulded, and extruded. It can also be purchased in sheet form.

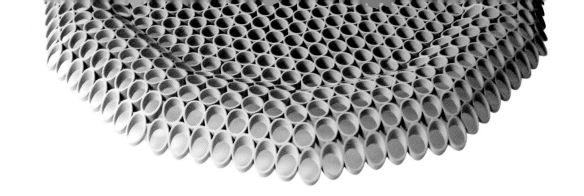

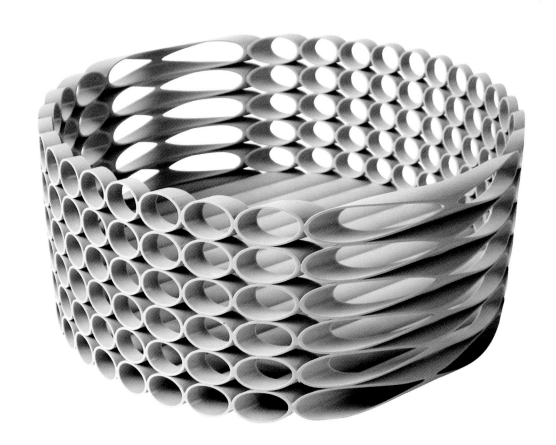

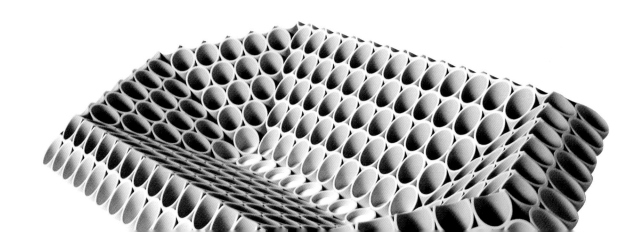

Ancient process and modern material

These organic-looking structures have a very unlikely origin. Turned on a lathe using a form of PVC ⬎ usually used for conduit tube, these pieces use a modern industrially produced pre-formed material, with a craft process ⬎.

The designers are not experimenting with the raw material in the way Gaetano Pesce ⬎ or Bobo Designs do ⬎, but instead use industrial pre-formed, extruded material intended for other functions and transform these through an intermediary step in another product. The simple angular cuts give unpredictable shapes, providing a semi-solid form. The objects are produced from a variety of solid and tubular PVC parts. The individual tubes are first glued together into a block. Depending on the final shape they are either turned or cut using a band saw. The forms are kept deliberately simple in order to reveal the idea rather than a shape. The tube diameters vary from 50mm to 16mm.

Contenants
Client: Self-initiated project
Designer: Dela Lindo
Launched: 2000

Dimensions	**Largest 250 x 400mm diameter**
	Smallest 150 x 300mm diameter
Production	**Turned PVC tube**
Material Properties	**Excellent resistance to chemicals**
	Good toughness and rigidity
	Can be made stiff and strong
	Easy to process; Relatively low cost
	Good clarity; Good weather resistance
	Flame retardant
Further Information	**www.vinylinfo.org, www.basf.de**
	www.oxyvinyls.com
Typical Uses	**Pipe; guttering; shoes; cable insulation; toys; injection-moulded housings for products; extruded panel products; glazing; packaging; credit cards**

more: PVC 024, 035, 038–039, 047, 050–051, 058–059, 065, 084, 092, 122–123; Craft Process 051, 055; Pesce 026; Bobo 041, 088

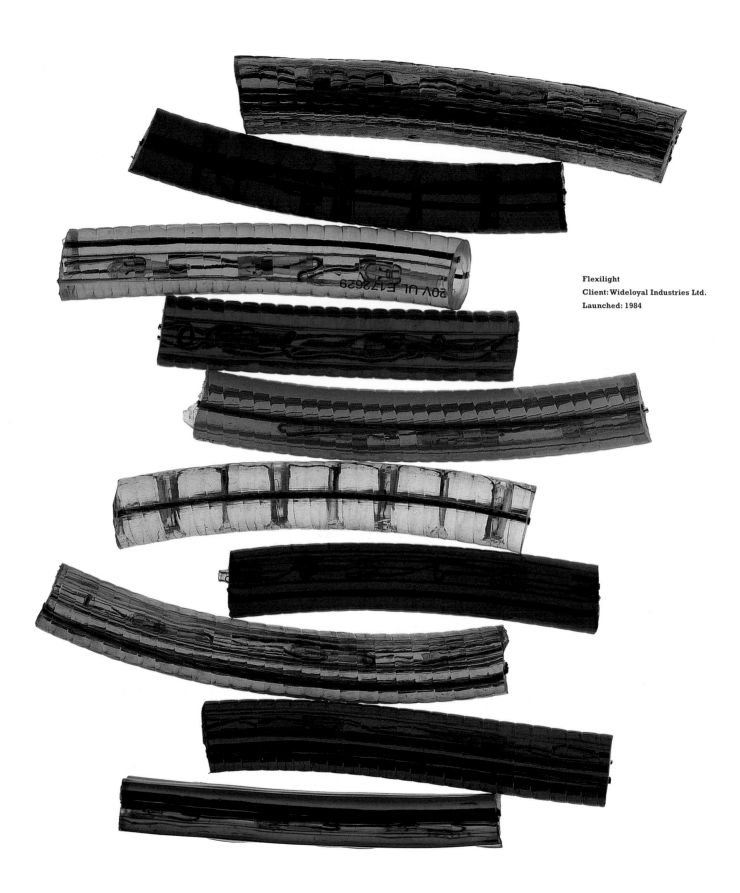

Flexilight
Client: Wideloyal Industries Ltd.
Launched: 1984

A series of tiny LEDs encapsulated in a flexible tube of light is the principle behind this light fitting. Go to most countries in the world and you will find this lighting-as-rope concept decorating the outside of public buildings or used to decorate the trees at Christmas in cities. Because the bulbs are sealed within this PVC ⬎ skin it is impossible to replace them. The miniature bulbs in the Flexilight are made with special Fuse-bulbs so that only the defective bulb will go off without affecting the other bulbs in the series.

The light is the perfect application of moulded PVC. It is categorised as a commodity plastic, the lowest end of the scale for plastics in terms of cost. It is therefore ideal for this application where large amounts of the material are needed. This fact combined with the ability of PVC to be altered and added to creating many grades makes it the natural solution for low-cost consumer products.

Rope lighting

Dimensions	Standard stock material supplied as 50m and 100m lengths
Production	Pultruded PVC
Material Properties	Additives can give it a large range of properties
	Easy to process; Easy to colour; Versatile
	Good corrosion and stain resistance
	Cost effective; Good rigidity
	Excellent outdoor performance
	Good resistance to chemicals
Further Information	www.wideloyal.com.hk
Typical Uses	Packaging; dip moulding; drain pipes; domestic appliances; credit cards; rain coats; car interiors

more: PVC 024, 035, 038–039, 047, 051, 058–059, 063, 084, 092, 122–123

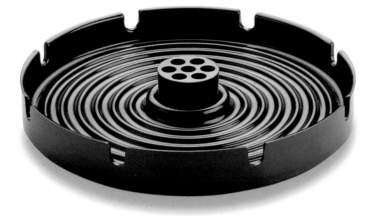

Posacenere (Ashtray)
Designer: Anna Castelli Ferrieri
Client: Kartell
Launched: 1979

It's a heavy, rigid material with the potential for a high-gloss finish. It imparts absolutely no smell or taste to food and feels hard, dense, rigid and unbreakable. Melamine ↘ is from the same family of thermosets as urea-formaldehyde ↘ and phenolic resins ↘, although it is more expensive than the other members of the group. The hard, shiny, non-porous surface is partly why it has been a popular alternative to ceramics in the design of dishes, plates and bowls.

Low-volume production

Dimensions	3 x 13cm diameter
Production	Injection moulded
Material Properties	Odour free; Good electrical insulation
	High impact resistance; Stain resistant
	Fire resistant; Heat resistant; Easy to colour
	Excellent resistance to chemicals
	Scratch resistant; Very high gloss;
	Limited production methods
Further Information	www.perstorp.com, www.kartell.it
Typical Uses	Handles; fan housings; circuit breakers; ashtrays;
	coat buttons; dinnerware; plastic laminates

In the 1930s melamine compounds became early replacements for Bakelite due to their ability to absorb and retain a range of colours. The 1950s were the heyday for moulded melamine when it was widely used for bright, multicoloured tableware products.

Today it is available as a compound for moulding but is probably used more as a resin for binding paper in plastic laminates ↘. As a raw material it is translucent but the addition of certain fillers, commonly cellulose ↘, can provide greater strength, stability and easier colourability. In terms of production it can be injection moulded and compression moulded, which uses powder and can give a superior finish. Its superior heat resistance makes it a perfect material for ashtrays as illustrated with the Anna Castelli Ferrieri ashtray for Kartell ↘.

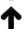

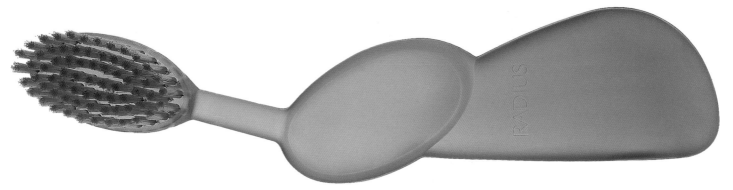

Radius Original Toothbrush
Client: Radius
Designer: James O'Halloran
Launched: 1982

Tasteless

The daily ritual of brushing our teeth is as old as the Egyptians, who used small branches where the ends were frayed into soft strands. Until the invention of Nylon ➘ in the 1930s, bristles were made from wild boar or horsehair. Cellulose propionate is produced by only one company in the world, Eastman Chemicals. It is one of the very few plastics derived from a renewable source and has been used in production since 1928. Used in toothbrushes it offers an alternative to its closest cousin, cellulose acetate ➘, which has a slight sharp taste in the mouth.

The Radius toothbrush company was started in 1982 by two architects who wanted to provide people with a 'comfortable and enjoyable' toothbrush: 'soft Nylon bristles, large head area for low pressure and a comfortable handle.'

Dimensions	**163 x 40mm**
Production	**Injection moulded**
Material Properties	**No taste; Warm feel**
	Distinctive visual appearance
	Lightweight; Easy to process
	Good range of visual effects; Good transparency
	Excellent gloss finish; Good elasticity
	Excellent impact resistance
	Made from renewable source
Further Information	**www.radiustoothbrush.com**
	www.eastman.com, www.dupont.com
Typical Uses	**Tool handles; hair clips; toys; goggles and visors; spectacle frames; toothbrushes; photographic film**

more: Nylon 034, 091, 093, 098, 100, 118; Cellulose Acetate 034, 048, 061, 066

'Until now the process of making any object could be summarised as one or more of the following:

1. Waste: chip, carve, turn, mill, chisel, i.e. the removal of excess material
2. Mould: injection moulding, casting, blow moulding and to some degree, extruding. i.e. pouring material as a liquid to take the form of its vessel and then harden
3. Form: bending, pressing, hammering, folding, vacuum forming i.e. a sheet material forced into a shape
4. Assemble: welding, gluing, bolting etc. i.e. joining parts together by any means

Now, there is a fifth way – GROW!' Ron Arad

Not Made by Hand
Not Made in China
Distributor: Gallery Morman
Designers: Ron Arad,
Geoff Crowther,
Yuki Tango,
Elliott Howes
Launched: 2000

The fifth way

All the objects you see in this collection were 'grown' in a tank by computer-controlled laser beams; the objects themselves could not possibly have been made by any of the four processes listed above.

Proclaimed by Ron Arad ↘ as the 'fifth way' of making things, Selective Laser Sintering (SLS) technology has traditionally been used by engineers to produce a rapid prototype of a product. The process starts by taking a 3D computer image and sending it to a machine that makes a perfect reproduction of the design. A laser beam is sent through a polyamide ↘ powder, which, at selected locations, is hardened into a solid material. Components are built as a series of layers. The fact that the powder is a solid means that parts do not need the supporting struts required for another rapid-prototyping process, stereolithography, that uses a liquid polymer instead of a powder.

Dimensions	**Various**
Production	**Selective Laser Sintering (SLS)**
Material Properties	**Good for working prototypes**
	Rough surface that can be improved
	by post finishing
	Higher cost than stereolithography
	Good for parts that require
	high mechanical and thermal resistance
	Can produce characteristics
	comparable to injection-moulded parts
Further Information	**www.materialise.be**
	www.ronarad.com
Typical Uses	**Functional products with snap fits; live hinges;**
	thermally and mechanically loaded parts

070

Surface as brand

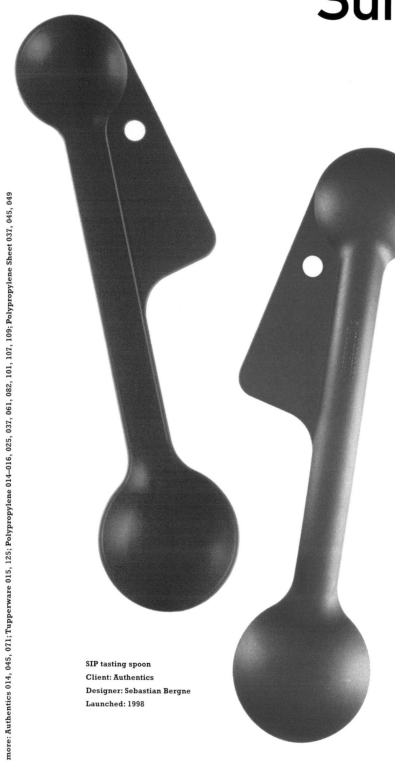

The German manufacturer Authentics ↘ has become synonymous with stony, matt, sorbet-coloured translucent plastic in the 1990s as Tupperware ↘ did with shiny, waxy, brightly coloured plastic in the 1950s. No modern home is without an Authentics product or at least a copy of one. They are known for modern interpretations of utilitarian products that subtly convey functions of modern living.

Authentics has led the way with polypropylene ↘, a fashionable material in both moulded and sheet ↘ form. The large areas of flat plastic are susceptible to scratches and imperfections which the matt texture can hide. The use of injection moulding means that individual products can be produced at a price to suit their purpose. The tasting spoon is designed to allow you to cool hot soups or sauces by passing them from one bowl to the other before drinking. Hygienic, heat-resistant polypropylene avoids burnt lips.

SIP tasting spoon
Client: Authentics
Designer: Sebastian Bergne
Launched: 1998

Dimensions	**230 x 55 x 15mm**
Production	**Injection-moulded polypropylene**
Material Properties	**High heat resistance**
	Excellent resistance to chemicals
	Low water absorption and permeability to water vapour
	Can be flexed thousands of times without breaking
	Good balance between toughness, stiffness and hardness
	Easy and versatile to process
	Relatively low cost
	Low density; Low coefficient of friction
Further Information	**www.dsm.com/dpp/mepp**
	www.basell.com, www.dow.com/polypro/index
Typical Uses	**Garden furniture; food packaging; bottle crates**

Acrylonitrile-Butadiene-Styrene (ABS) ↘, a thermoplastic ↘ co-polymer resin, offers a good balance of properties that can be tailored to suit specific needs. Its main physical properties are its hardness, toughness and rigidity.

The resin grades of ABS consist of a blend of an elastomeric (rubber) element, which is the polybutadine, providing good impact strength, an amorphous thermoplastic of styrene which gives processing ease (easy flow in the mould), and acrylonite which helps with hardness and rigidity and resistance to chemicals. The control of these three monomers gives designers the flexibility needed for the final application. It is probably due to this that it is used widely in domestic appliances and white goods. Although not as tough as some other engineering polymers it offers excellent cost effectiveness.

Inspired by childhood memories, Stefano Giovannoni created a range of plastic products for Alessi that has done much to rebrand this Goliath of contemporary design. He has allowed the materials to be fully utilised to create brightly coloured characters that respond to our own memories. ABS is used in the hard-wearing application of a tin opener, which has a special mechanism that allows for the opened part of the tin to be re-used as a lid.

Blended

Dimensions	190 x 65mm
Production	**Injection-moulded with steel mechanism**
Material Properties	**High-impact strength even at low temperatures**
	Good stiffness and mechanical strength
	Good scratch resistance; Low specific gravity
	Relative thermal index up to 176°F (80°C)
	Good dimensional stability at high temperatures
	Flame resistant; Easy to process
	Can achieve a high gloss; Easy to match colours
	Cost-effective compared with other thermoplastics
Further Information	**www.alessi.com, www.geplastics.com**
	www.basf.de
Typical Uses	**Lego; automotive consoles; door panels;**
	exterior grilles; domestic appliance housings

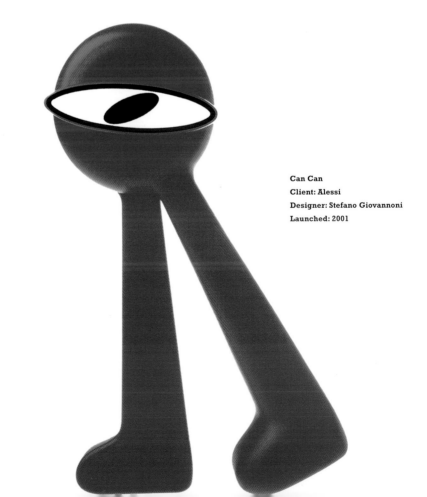

Can Can
Client: Alessi
Designer: Stefano Giovannoni
Launched: 2001

more: ABS 027, 060, 075, 077, 097, 121; Thermoplastic 022, 027, 029, 072, 090, 100–101, 109, 127

072

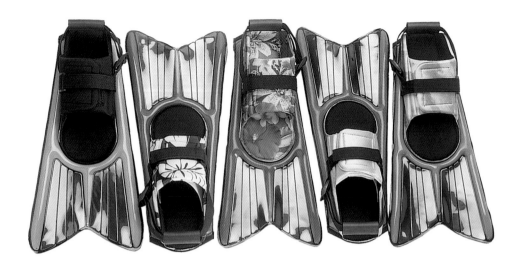

FAB FORCE™
Designer: Bob Evans
Launched: 1999

Flip back

TPEs ↘ offer the feel of rubber with the processing capabilities of thermoplastics. TPE is a generic term used to describe a family of thermoplastic elastomers which include TPOs (thermoplastic olefins) and TPSs (thermoplastic styrenes). These are all engineering polymers, which offer flexibility and toughness for most conditions. TPEs can generally be moulded by injection moulding, blow moulding or extruding.

The use of TPEs is perfect for the 'snappy blade' characteristics of diving fins. The FAB FORCE™ is manufactured by using low-tech tooling and casting polyurethane in a mould with layers of fabric. Bob Evans, the designer and owner of FAB FORCE™ says, 'I participate in the fabrication of every mould. To realise everything I want to create, I had to find a way to eliminate moulds from the design and production.'

Material Properties	Flexible, Easy to colour
	Available in a range of Shore hardnesses ↘
	Can be extruded, injection moulded and blow moulded
	Can be reinforced with glass fibre
	Keeps its properties at low temperatures
	Can be painted; Recyclable
	Good resistance to tearing and abrasion
	Good resistance to weather and seawater
	Good resistance to oil and chemicals
Further Information	www.forcefin.com
	www.aestpe.com
	www.basf.com
Typical Uses	Automotive; mechanical engineering; sports shoes; shock absorbers; side trims for cars; hand tools; ski boots; snow chains

more: TPE 086, 090, 127; Shore Hardness 090, 118, 127, 150

Use it in the oven

Working with silicone ↘ is like baking a sponge cake. Like cakes with subtle alterations to the ingredients silicone can take on a multitude of forms and functions. So by adding carbon or silver particles to silicone it can be made to be as conductive as copper wire or an effective insulator. One of the main distinctions silicone has over conventional rubbers is its ability to withstand high temperatures. However, beyond this, it also has an ability to be adapted to form different grades, and it feels and looks great.

The W2 products are made from a grade of high-consistency, heat-cured silicone. These home accessories utilise the ability of silicone to be produced in a range of colours, transparencies and toughnesses. They have a milky translucency (silicone can also be made to be optically clear, photochromic and fluorescent), but with their soft, squidgy, jelly-like feel they are also interesting to the touch. However, silicone is not limited to accessories in the home — it is even heat-resistant enough to cook bread in.

Dimensions	Soapy Joe 107 x 98 x 25mm
Material Properties	Large range of possible grades
	Easy to colour; Expensive
	Can be made to be optically clear
	Can withstand a wide range of temperatures
	UV resistant; Good tactile qualities
	Food safe; Chemically inert
Further Information	www.w2products.com, www.gesilicones.com
Typical Uses	Electrical encapsulation; tubing; high temperature 'O' rings; heat shrinkable tubing; surgical equipment; structural adhesives; baby teats; keypad mats; insulation on power lines; oven door seals; baking trays

Soapy Joe
Client: W2
Designers: Jackie Piper, Vicky Whitbread
Launched: 2000

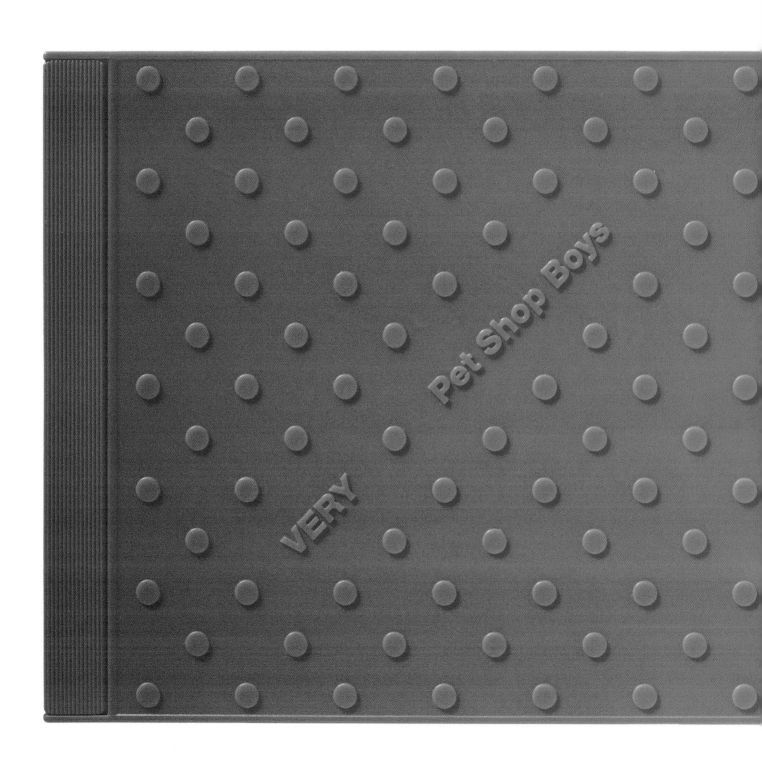

Surface design

A packaging icon of the 1990s made from the same material as a conventional jewel case, this product screams out its difference to other CD packaging by featuring a series of orange studs on an orange box. In order to appreciate how much of a departure this product is, you only have to look at how minor the design elements are but how radical the packaging appears. Even the arrangement of the studs is controlled to accommodate the suction pads, which hold the CDs in the case.

Polystyrene ⬎, like so many polymers, was discovered by accident. Styrol (styrene) was discovered in the middle of the 19th century but was not commercially exploited until the 1930s. It is connected with the styrene family which includes ABS ⬎, SAN, and SMA ASA co-polymers. Today it is one of the most widely used plastics for a massive range of applications.

Dimensions	**Standard: 143 x 125 x 10mm**	**Very**
Production	**Injection moulded**	**Client: Parlophone Records**
Material Properties	**Excellent clarity; Good stiffness**	**Designer: Daniel Weil**
	Easy to process; Easy to colour	**Launched: 1993**
	Relatively low cost compared with	
	other polymers; Good transparency	
	Very low water moisture absorption	
	Easy to mould and process	
	Good dimensional stability	
Further Information	**www.dow.com/styron/index.htm**	
	www.huntsman.com, www.atofina.com	
Typical Uses	**Packaging; toys; coat hangers; household and**	
	electrical appliances; model kits; disposable cups	

more: Polystyrene 112, 121; ABS 027, 060, 071, 077, 097, 121

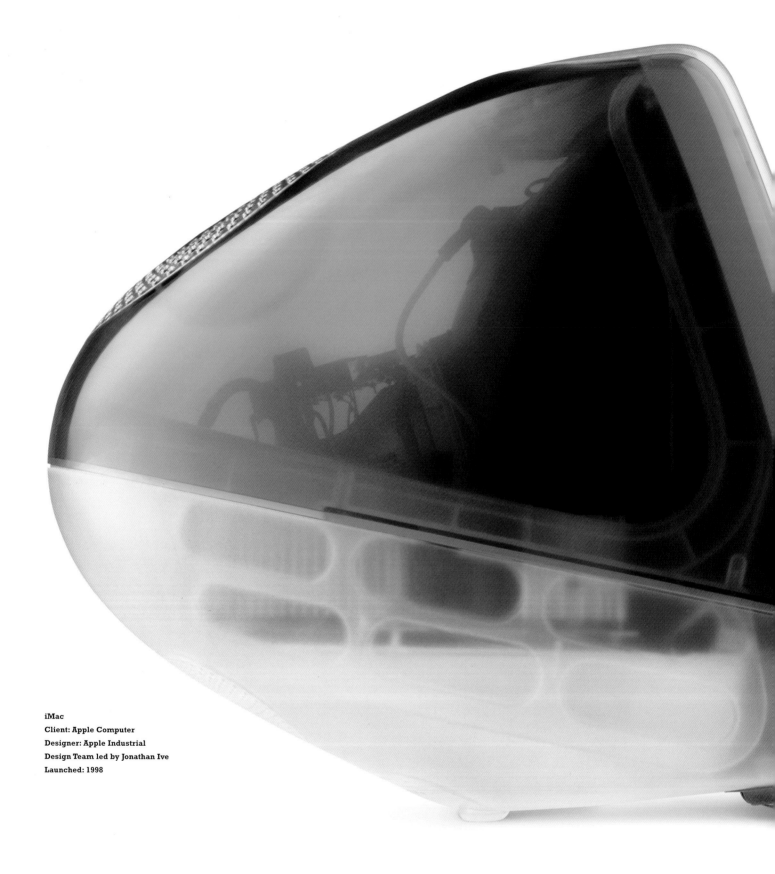

iMac
Client: Apple Computer
Designer: Apple Industrial
Design Team led by Jonathan Ive
Launched: 1998

Steamy shower

Apple's statement and reaction against the bland, beige ABS ⬎ computer boxes needed a new material. It had to provide the opportunity for people to be aware of the technology at the heart of the machine, but without showing too much of the ugly internal workings that remind them of how dependant they are on something they know nothing about.

The design team looked at various ways of creating the diffused, translucent, frosty quality. Analogies were made with the effect of a steamy shower, where you don't see everything. The range of boiled-sweet colours (sweet manufacturers were consulted for this aspect) and surface treatments like the ribbed effect exploit the transparency of the casing, the ribs being on the inside to maintain a smooth outer surface. Polycarbonate ⬎ offers excellent transparency and colourability combined with a very high degree of toughness. The evolution and advancement of the internal technology meant that later graphite models of the iMac could be more transparent as the internal workings became more refined.

Dimensions	**381 x 381 x 435mm**
Production	**Injection moulded**
Material Properties	**Excellent range of colours**
	Excellent optical clarity; Easy to process
	Outstanding impact resistance
	Available as transparent, translucent and opaque
	Excellent dimensional stability, even at high temperatures
	Good heat resistance up to 125°C
	Flame resistant; UV stable
	Durable; Recyclable; Non toxic
Further Information	**www.apple.com, www.geplastics.com**
	www.dsmep.com, www.teijinkasei.com
Typical Uses	**Safety helmets; eyewear; compact discs and DVDs; kitchen containers; computer housings; architectural glazing; mobile phone housings**

more: ABS 027, 060, 071, 075, 097, 121; Polycarbonate 028, 097, 099

How to use:
- Pour very hot water, approximately 90°C, into a bowl or pan
- Immerse the handle in the water for approximately five minutes until soft
- Remove from water with tongs or other safe equipment
- While still soft but cool enough to hold, form the handle into the desired shape to fit the user's needs
- When satisfied with the shape place handle into cold water to harden and retain this new shape. The metal head part is pushed into the handle while the latter is soft (no bonding agent is used). Therefore it is possible to turn the head part into a desired position to fit the user's needs whilst the handle is still soft

Warning:
- Head part becomes very hot when it is placed in hot water. Be sure to use oven gloves
- Do not place re-shaped handle in cold water while it is still on the user's hand or it may never be removed from the user's hand after cooling and hardening
- Do not expose to direct flame. Material is inflammable and will melt at a high temperature

Will
Client: AOYOSHI Co. Ltd.
Designer: Hiroshi Egawa
Launched: 1991

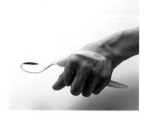

Warm it up

Dimensions	**Large fork 242 x 40mm; handle length 143mm**
Production	**Injection moulded**
Material Properties	**Wide variation in forms, physical and mechanical properties**
	Outstanding flex life and cut resistance
	Good abrasion resistance
	High tensile and tear strength
	Good chemical resistance
	High elasticity; Easy to colour
Further Information	**www.diaplex.co.jp (only in Japanese)**
	www.mediagalaxy.co.jp/aoyoshi/index.htm
Typical Uses	**Sheeting; car bumpers; bladders; fuel line tubing; packaging material; car body mouldings**

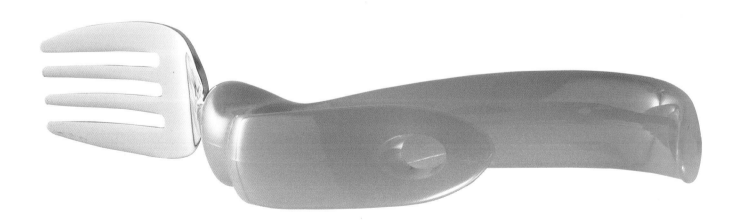

Glassy smooth

To deliver eight gallons of beer you would need 27lb of glass bottles or 8lb of steel. With polyethylene terephthalate (PET) ⤵ you only need 5lb. The use of plastic as a replacement for glass means you can take your beer into places that usually prohibit anything in glass.

PET is commonly used for food and soft drinks packaging. However, due to beer being more oxygen and carbon-dioxide sensitive PET was not suitable. Altogether there are five layers in each bottle; sandwiched between three layers of PET are two layers of oxygen scavengers which prevent oxygen getting in or out. Miller Brewing Company who launched its first plastic bottle in 2000, claim it keeps beer cooler longer than aluminium cans and as long as glass. It can also be resealed and is unbreakable.

Dimensions	**Height 210mm; diameter 70mm**
Production	**Injection-blow-moulded**
Material Properties	**Recyclable (PET is one of the most recycled plastic resins)**
	Excellent resistance to chemicals
	Excellent dimensional stability
	Tough and durable; Excellent surface finish
	Good impact strength
Further Information	**Continental PET Technologies**
	www.dsm.com/dpe
Typical Uses	**Food packaging; electrical products; soft drinks bottles**

Miller beer bottle
Client: Miller Brewing Company
Designer: Continental PET
Technologies
Launched: 2000

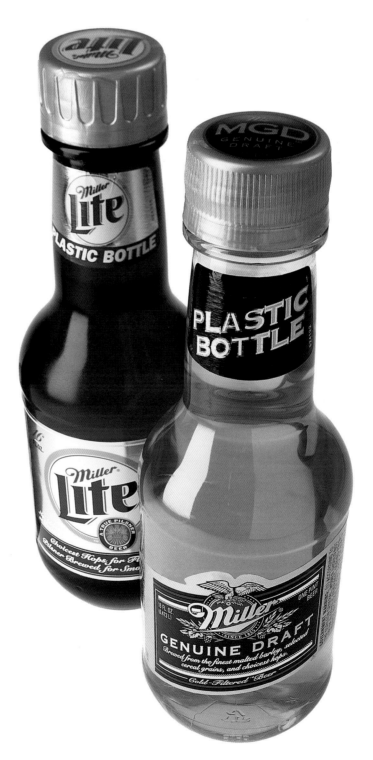

more: PET 118 ↑

081 Engineering

Strong, lightweight and soft

Aramid fibre ↘ is strong enough to moor the largest of Navy vessels and provide body protection against bullets, soft enough to use as gloves to protect against sharp metal and glass, and heat resistant enough to act as shielding in jet aircraft engines.

More commonly known as Kevlar®, like carbon ↘ and glass fibre ↘ it is available in various forms such as fabric and prepreg, thread, continuous filament yarn and floc. This fibre, which for the same weight-to-weight ratio is five times stronger than steel, was developed in 1965 by Stephanie Kwolek and Herbert Blades, two research scientists at DuPont. The shoe uses a sole plate made from Kevlar® which provides improved sole stiffness, while at the same time absorbing impact forces, spreading the load over the whole area of the sole.

Material Properties	Low thermal shrinkage
	Excellent dimensional stability
	High tensile strength at low weight
	Low elongation to break
	High cut resistance; High toughness
	High chemical resistance
	High modulus (structural rigidity)
	Low electrical conductivity
	Flame resistant
Further Information	www.dupont.com/kevlar/whatiskevlar.htm
	www.hexcel.com
	www.dupont.com/kevlar/europe/
	www.e-composites.com/seal.htm
	www.saati.it/seal/ita/default.htm
Typical Uses	Adhesives and sealants; composites; body armour; bullet proof vests

more: Aramid Fibre 082, 101; Carbon Fibre 030, 087; Glass Fibre 027, 072, 087, 091, 109, 127

Tough and flexible

History shows us many examples of non-metallic materials being used to replace metals. Leathers, horn, wood and ceramic all have their valuable physical properties and uses. The introduction of plastics has meant that these components could be precisely controlled and moulded to fulfil any requirement.

Acetal ⬎ is one of the stiffest and strongest polymers. Since its introduction in the 1960s its unique properties have bridged the gap between metals and other plastics within a huge range of applications from snap-fit clips, where it is used for its high spring resistance, to cheap cigarette lighters, where it is used for chemical resistance. It's not flexible in the same way as certain elastomers ⬎ or polypropylene ⬎ but is much stiffer and generally not as pretty or as tactile.

Material Properties	High rigidity; Natural lubrication
	High mechanical strength
	Excellent fatigue resistance; Gloss finish
	High resistance to repeated impacts
	Toughness at low temperatures (down to -40°C)
	Excellent resistance to chemicals
	Excellent dimensional stability
	Good electrical insulating characteristics
	Good temperature range; Resilient
Further Information	www.dupont.com/enggpolymers/europe/
	www.basf.com
Typical Uses	Fasteners; shower heads; hardware housings; snap fit buckles; clothes pegs; rollerblade breaks

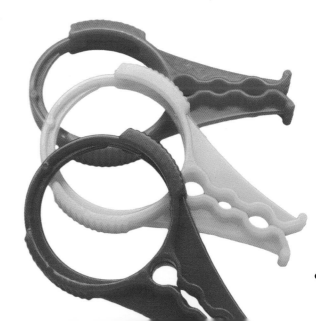

Delrin® clothes pegs
DuPont

more: Acetal 097; Elastomers 038, 071–072, 086, 090, 097, 127; Polypropylene 015–016, 025, 037, 045, 049, 061, 070, 107, 109

Imagine a material that feels like skin. It breathes and stretches, but can be cast or formed into any shape at any thickness. These properties were first applied in the medical and orthopaedic industry as cushioning for hospital patients. Technogel® is, however, one of those materials that through experimentation has branched into more popular domestic arenas.

Like skin

Technogel® is both a liquid and a solid at the same time. Products are produced by pouring the liquid into moulds, which means it can be easily cast to include other things. RVS (Royal Vacuum System) is a patented system, which consists of vacuum-fusing different components into a single item, without the need for stitching or glueing. This system is applied by Royal Medica in the production of bed cushions where a thin urethane film is fixed to the Technogel®. Other potential covers include Lycra®, PVC ↘, PU, leather and textiles. In the sheet form shapes can easily be stamped out or cut. Its main advantage over similar water- or silicone-based gels is that it does not contain plasticisers. This means that it does not lose its basic properties over time. It's the only gel that doesn't break, harden or age.

Dimensions	**1 x 0.5m sheets of varying thicknesses**
Material Properties	**Good pressure distribution**
	Breathable (good water absorption and release)
	Good recovery capability
	Easy to combine with decorative materials
	High shock absorption; Sheer force absorption
	Adjustable Shore hardness
	High elasticity; Colourfast; Can be glued
	Non-irritating to the skin
	Can be injection moulded
Further Information	**www.royalmedica.com**
	www.selleroyal.com
Typical Uses	**Bicycle saddles; orthopedic seats/cushions; shoe insoles; office chairs; tennis racket handles**

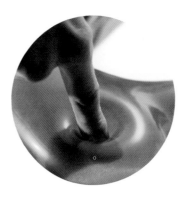

Technogel®
Client: Selle Royal

more: **PVC 024, 035, 038–039, 047, 050–051, 058–059, 063, 065, 092, 122–123**

James doorstop
Client: Klein & More
Designer: Winfried Scheuer
Launched: 1996

Dishwasher safe

When Winfried Scheuer began designing the James, he was asked to create a soft object that would not damage the door. The use of the material TPE ↘ also provided a good range of colour possibilities compared with the most obvious choice of using rubber.

Because the product is injection moulded in solid material the thickness at the thick end of the wedge needed to be controlled to stop sinkage marks forming. This happens when the inside plastic cools at a much slower rate than the outside surface. The dual function of the James was an outcome of a range of ideas that looked at the simple non-technology of everyday household items that had previously been ignored. It comes in five colours and if it gets grubby it will go in the dishwasher. A fairly hard but still very flexible grade of TPE gives the James a very tactile quality.

Dimensions	**180 x 50mm**
Production	**Injection moulded**
Material Properties	**Superior dynamic properties**
	Good cut and tear resistance at elevated temperatures
	Excellent oil, fuel and solvent resistance
	Excellent flex fatigue resistance
	Soft and flexible material; High resilience
	Good range of processing techniques
	Can produce excellent range of colours
Further Information	**www.glscorporation.com**
	www.aestpe.com
Typical Uses	**Hand grips; medical products; 'O' rings; piping; offshore cabling; shock absorbers; sports shoes; side trims for cars; ski boots**

more: TPE 072, 090, 127

Light Light
Designer: Takeshi Ishiguro
Launched: 1994

Hi-tech

Dimensions	**90 x 90cm**
Production	**Assembled from carbon fibre tube and rod**
Material Properties	**Distinctive surface finish**
	Great strength to weight ratio
	Easy to customise; Range of shapes
	Available in a range of colours
	Good chemical resistance
	Non-corrosive; Extremely durable
	Neutral to aggressive environments
	Good temperature range
Further Information	**www.globalcomposites.com**
	www.hexcel.com, www.carb.com
	www.composites.com
Typical Uses	**Boats; automobiles; sports equipment; civil engineering; aeronautical parts; rail transport; architecture; toys**

The Light Light uses composites to create a featherly structure. Composites refer to a combination of two materials, a fibre-based material and a resin. In most modern composites the resins are usually made of polyester or epoxy. The fibres can be glass ↘, carbon ↘, aramid ↘, polyethylene or even natural fibres. The use of modern composites was pioneered by the aerospace industry when traditional materials did not provide high enough strength-to-weight ratio.

Prepregs are continuous sheets of fibre that are impregnated with resin. Fibres are arranged either in one direction, know as unidirectional (UD) or as a fabric with fibres arranged in several directions. They are typically used for high-tech automotive and aeronautical body panels and can be processed by tube rolling, pressure or vacuum-bag processes and match moulding. Fibres embedded into specific thermoset resins is the most widely used process. The areas of the product that require the greatest strength have thicker layers of fibres.

more: Glass Fibre 027, 072, 082, 091, 109, 127; Aramid Fibre 082, 101; Carbon Fibre 030, 082

088

Tables of light

The idea of a flat sheet of plastic, which can reflect an even glow of light, has huge potential. The material is a light before you have even formed anything from it. It is a sheet of light waiting to be sculpted.

Prismex™ is the trade name given by Ineos for an acrylic panel which features a patented dot matrix screen-printed on to its surface. This allows the light to be reflected across the panel to produce a brilliant even illumination without the banding effect of conventional back-lit signs. Central to the design of both the Prismex™ Table and the Blow Prismex™ Pouffe is this lighting technology. Bobo Designs ⬎ were the first to exploit the unique characteristics of Prismex™ acrylic ⬎ sheet in the creation of contemporary furniture.

They experimented with its ability to produce an even, cool and thin layer of illuminated light across both flat and even thermoformed surfaces, generating an almost magical white glow. As with the Perspex in the Airwave table, the Prismex™ sheet in the products is 100 per cent recyclable.

Dimensions	**1800 x 1000 x 720mm**
Production	**Cast acrylic sheet**
Material Properties	**High energy efficiency; High melting point**
	Easy and versatile fabrication and processing
	Low-cost tooling
	Outstanding surface hardness and durability
	High print adhesion; Fully recyclable
Further Information	**www.ineosacrylics.com, www.perspex.co.uk**
	www.bobodesign.co.uk, www.lucite.com
Typical Uses	**Display; point of sale; interiors; furniture;**
	lighting; signage

Prismex™ Table
Bobo Designs
Designer: Tanya Dean,
Nick Gant
Launched: 1999

more: Bobo 041, 063; Acrylic 031, 040–041, 055

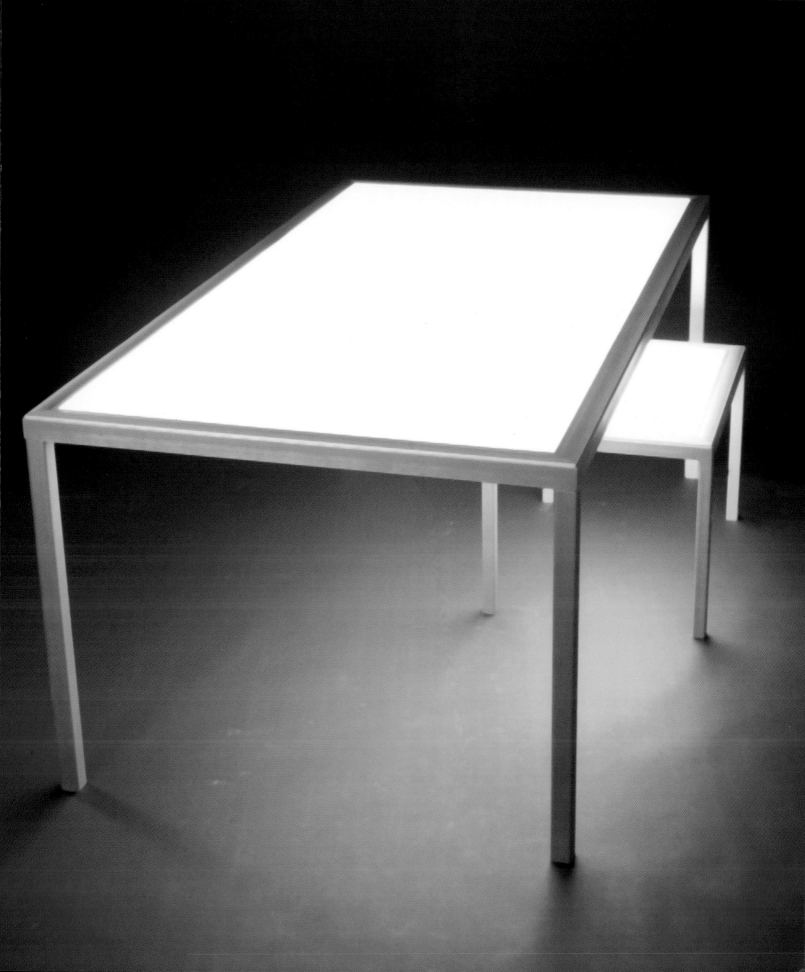

090

Mutation of plastic and rubber

Material Properties	**Exceptional toughness and resilience**
	High resistance to creep, impact and flex fatigue
	High flexibility at low temperatures
	Maintains properties at high tempatures
	High resistance to industrial chemicals,
	oils and solvents
	Good processing potential
	Good mechanical strength
	Excellent stretch and recovery characteristics
Further Information	**www.dupont.com/enggpolymers/products/hytrel**
	www.basf.com
Typical Uses	**Springs; hinges; impact and sound absorbing**
	devices; ski boots; textiles; furniture; engineering
	components; key pads

Hytrel® is a trade name given to DuPont's range of engineering thermoplastic elastomers ↘. It gives the flexibility of rubbers, the strength of plastics, and the processibility of thermoplastics. It is used in applications where mechanical strength and durability are required in a flexible component. Hytrel® is ideal for parts requiring excellent flex fatigue and ability to withstand a broad range of temperatures from -40°C to +110°C. It is highly resistant to tearing, flex-cut growth, creep and abrasion.

Hytrel® is available in a full range of grades known as Shore D hardnesses ↘. These range from a Shore D hardness of 72 which is quite rigid but still flexible to a Shore D hardness of 35 which feels like a piece of rubber. Special grades include those that are heat stabilised, flame retardant, and blow moulded. As with many polymers in their raw form the material comes in pellets, which are moulded into the final products.

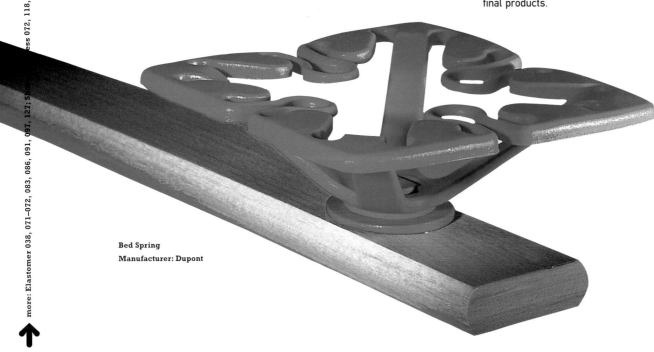

Bed Spring
Manufacturer: Dupont

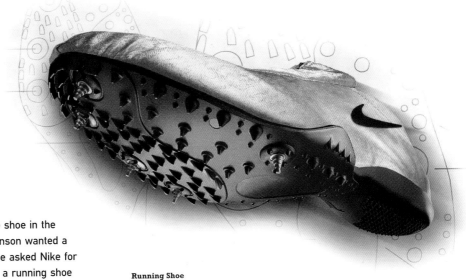

Running Shoe
Designer: Nike

It has to be the most expensive shoe in the world, but sprinter Michael Johnson wanted a new pair of running shoes so he asked Nike for some ideas. Their solution was a running shoe with a sole that when it had been designed weighed in at a featherly 30g.

The shoe is made using Zytel®, a DuPont Nylon polymer, and is a good illustration of a blend of materials coming together to fulfil a specific function. The main material is the Nylon ↘ which is reinforced by 13 per cent glass fibre ↘ to give it even more strength than it already has. This is combined with an elastomer ↘ to give the material flexibility without breaking.

Nylon is another DuPont material which was invented about 70 years ago. The name it gives to its family of mouldable Nylon resins is Zytel® which distinguishes it from its large range of applications within the textile industry. Nylon resins are usually referred to as Nylon 6 or Nylon 6.6. The numbers are based on the number of carbon atoms in its monomer.

Material Properties	**High tensile strength**
	Excellent fatigue resistance
	Excellent flow properties
	Performance can be improved by fibre
	Withstands repeated impact
	Offers low coefficient of friction
	Fast moulding cycles
	Resists abrasion and most chemicals
	Provides electrical insulation characteristics
Further Information	**www.dupont.com/enggpolymers/europe/news**
Typical Uses	**Automotive; bearings; cams; gears; electrical appliances; industrial and consumer products**

Featherly

more: Polyamide 016, 018, 069, 093; Nylon 034, 067, 093, 098, 100, 118; Glass Fibre 027, 072, 082, 087, 109, 127; Elastomer 038, 071–072, 083, 086, 090, 097, 127

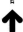

Light thread

Dimensions	**Diameter 80 x 50cm and 45 x 20cm**
Production	**Nylon thread and inflatable PVC, with**
	compact fluorescent bulb
Material Properties	**Excellent abrasion resistance**
	High tensile strength; Excellent flow properties
	Excellent fatigue resistance
	Provides electrical insulation characteristics
	Withstands repeated impact
	Offers low coefficient of friction
	Fast moulding cycles
	Resists abrasion and most chemicals
Further Information	**www.via.asso.fr**
Typical Uses	**Tennis ball covers; upholstery; military apparel;**
	abrasive pads; fishing line; parachutes; aircraft
	tyre reinforcement; stockings; carpets

The work of this French designer is linked by his interests in re-evaluating and questioning commonly used processes and materials which can be seen from his turned wooden lampshade that uses wood to diffuse the light and his self-assembly foam chair ⬎. The essence of this lighting design is its use of a forest of dyed Nylon ⬎ threads suspended in an inflatable structure, creating diffracted light. The design is less about the design of a lighting form and more about the process of fabrication.

The Nylon thread was provided by the textile manufacturer Tissavel, and is usually used in aerospace applications. The light is about a transfer of technologies where an industrial thread is used for a structural function within a domestic lighting application. The originality of the light comes from this unexpected utilisation of a material and the soft light it gives.

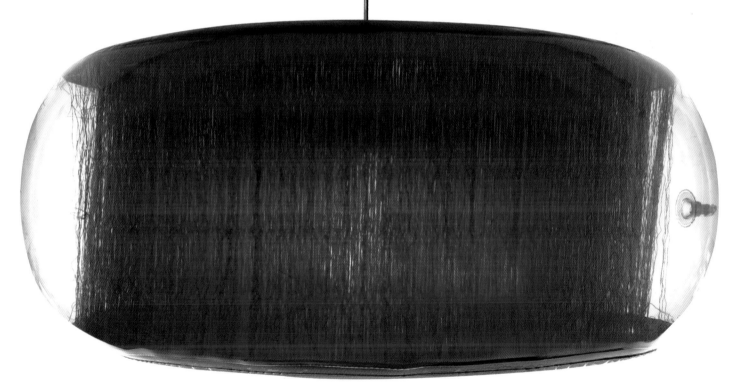

Lamp
Designer: Francois Azambourg

more: Polyamide 016, 018, 069, 091; Azambourg 019; Nylon 034, 067, 091, 098, 100, 118

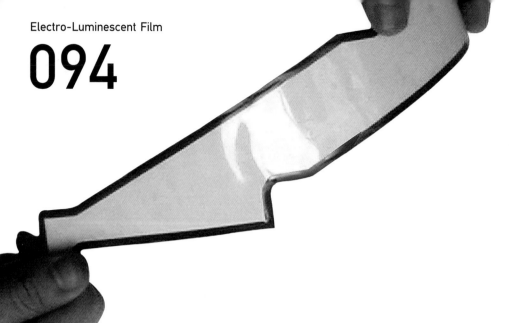

The use of polymers as light-emitting devices is not new. The technology of EL film has been around since the 1970s. But a piece of plastic film less than 2mm thick which illuminates when you attach it to a battery still has a science-fiction 'wow' factor to it and a huge as yet unfulfilled potential. As with many new ideas this design was not a brief from a manufacturer but was a self-initiated project inspired by the experience of a user who was also a designer.

Using new bicycle frame geometry as a starting point, the product uses an existing material that offers 360° coverage of light, as opposed to conventional lights which are mono-directional. The wrap-around shape of a toilet-roll tube inspired the original pattern shape. The light is powered by a 9-volt battery which is connected by a drive unit to convert the power to a 110-volt AC current which is needed to light the film. The battery and drive unit are both housed under the seat. The film itself is mounted on to a thin sheet of neoprene, which acts as cushioning and grip for the film. The glow from this thin film provides enough light for the cyclist to be seen from a good distance, also giving 180–200 hours of continuous use.

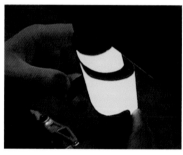

C360 Security Light
Client: Self-initiated project
Designer: Mark Greene
Launched: To be announced

Dimensions	**Thickness 3.5mm (including neoprene base)**
	Weight 7g (not including battery)
Production	**Die-cut EL film**
Material Properties	**Uniquely thin displays**
	Will eventually become extremely cost effective
	Versatile application; Good clarity of image
	Waterproof; Flexible
	Can be made transparent
	Excellent colour range
Further Information	**www.opsys.co.uk**
	www.uniax.com/165-0021.htm
Typical Uses	**Armbands; vests; helmets for cyclists; mobile telephones; video telephones and palm-top computers; furniture; ornamentation; advertising; smart cards; lighting**

No longer science fiction

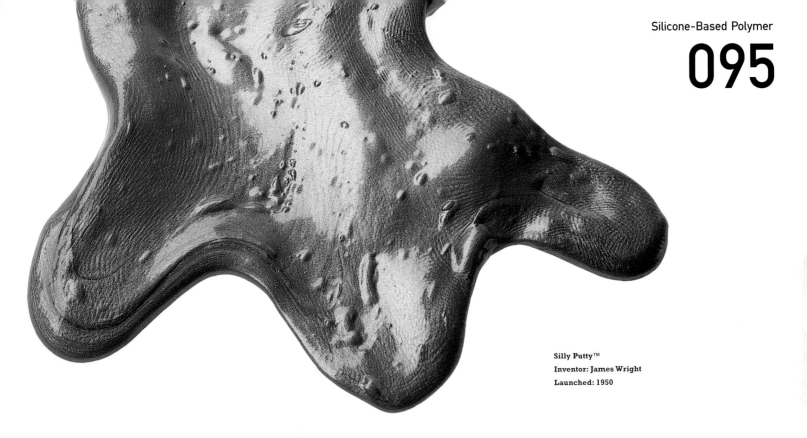

Silly Putty™
Inventor: James Wright
Launched: 1950

Material Properties	**Gradually flattens with gravity**
	Bounces back 80% of the height from which it is dropped
	A dilatant compound i.e. acts like a solid and retains its shape if pressure is applied quickly to it and behaves more like a liquid and is easily moulded if pressure is applied slowly to it
	Cooling greatly improves its ability to bounce
	Shaped into a boat it will float on water
	Moulded into a ball it will sink
	Non-toxic and non-irritating; Highly elastic
Manufacturer	**Binney & Smith (since 1977)**
Further Information	**www.sillyputty.com**
Typical Uses	**No other current applications**

In 1943, a Scottish engineer, James Wright, working for General Electric in Connecticut, was in his laboratory mixing substances in test tubes. He happened to combine boric acid and silicone oil and this compound became 'polymerised'. Wright extracted this gooey concoction from the test-tube and while doing so threw some on the floor. To his amazement, it bounced and so bouncing putty was born.

Determined to find a practical use for his creation, but to no avail, eventually Silly Putty was introduced at the International Toy Fair in New York in 1950. After great persistence, a few of the larger toy outlets decided to take on Silly Putty and the rest is history. Fifty years on, Silly Putty has become an American toy classic, quite literally a household name. You can now get glow-in-the-dark and heat-sensitive putty. Over 300 million putty eggs have been sold since 1950.

Bouncy stretchy

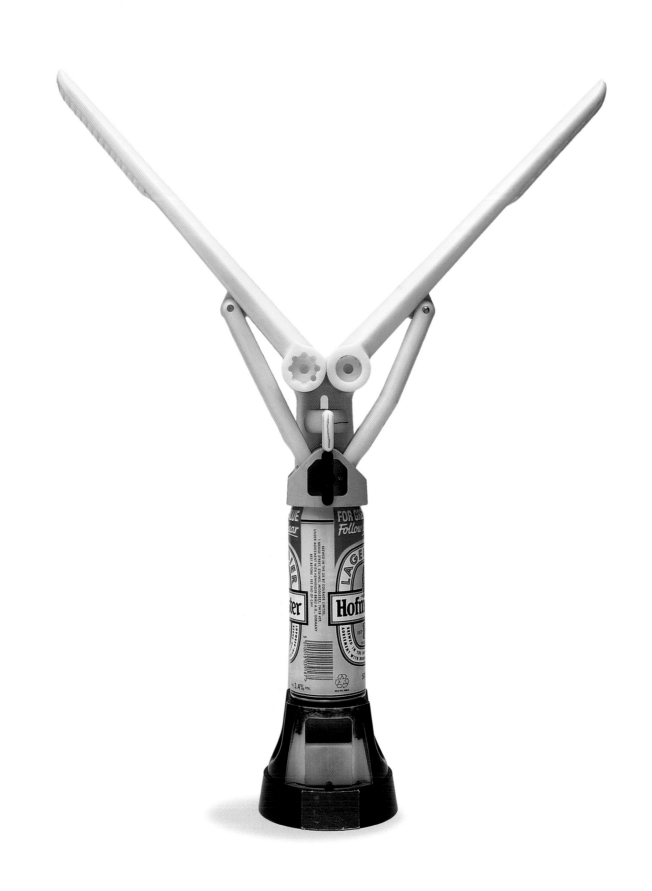

Attila can crusher
Client: Rexite Spa
Designer: Julian Brown
Launched: 1996

Not just an engineering product but a beautiful product. Avoiding the more expensive choice of material such as polycarbonate ↘ and acetal ↘ this product uses its own form and structure to fulfil this Herculean function. To enable 600 Newtons to crush an aluminium or steel can to 22mm in height it uses ABS ↘ in a series of intelligent webs and supports.

The original prototype was made in MDF as a test for the mechanism. Attila was then prototyped from a solid block of Delrin®, a very rigid material which proved the point that a polymer could stand up to the job. It proved in fact that the acetal was even too strong. This led to the choice of ABS as the material for the final product.

Attila addresses the environmental concerns of excessive consumption with one of the biggest symbols, the drinks can. The design brings the product in from the garage and into the kitchen. It was therefore important that in terms of materials and aesthetics Attila addressed the physical requirements that were placed on it, in a form which people would want in their homes.

Dimensions	**385 x 120mm**
Production	**Injection-moulded ABS body; Polycarbonate clip and ring; Elastomeric base**
Material Properties	**High impact strength even at low temperatures**
	Good scratch resistance; Flame resistant
	Good stiffness and mechanical strength
	Low specific gravity; Easy to process
	Relative thermal index up to 176°F (80°C)
	Good dimensional stability at high temperatures
Further Information	**www.rexite.it, www.geplastics.com**
	www.basf.de/plasticsportal, www.dow.com
Typical Uses	**Toys; automotive consoles; door panels; exterior grilles; domestic appliance housings; medical devices; business equipment; phone housings; building and construction products**

Brutally effective

more: Polycarbonate 028, 077, 099; Acetal 083; ABS 027, 060, 071, 075, 077, 121

098

Machine washable

Production	Standard woven yarn with an electrically conductive coating
Material Properties	Capable of switching and sensing technology
	Can detect X-Y positioning
	Can be stitched and woven into garments
	No need for rigid circuitry
	Can be washed
	Soft and flexible
Further Information	www.elektex.com
Typical Uses	Mobile communications; text interfacing; toys; car parts; healthcare; sports and leisurewear

We no longer have to rely on rigid, or semi-rigid materials for our electronic products. ElekTex™ is a fabric that is conductive, intelligent and responsive to touch, with the ability to process data. Elektro Textiles is a UK-based company founded in 1998 to develop and licence this technology for use in defined market sectors. The material offers a soft, flexible, lightweight interface, which was previously only available with rigid materials.

Products made using ElekTex™ technology act in the same ways as conventional textiles in that they can be washed and worn. The fabrics make use of standard Nylon ⬎ or polyester with an electrical conductive coating. The potential for future electronic products that do not need to rely on a rigid panel to hold the electronics is massive. The freedom to create wearable technology where communications devises are built into the clothes we wear begins to blur the boundaries of technology. Technology will no longer be seen as a separate entity contained in a plastic box, but as an integral part of our surroundings. Current products range from car seats designed to optimise comfort and load distribution to soft phones and foldaway keyboards.

Conference phone
ElekTex™
Launched: 1998

Make no mistake, polycarbonate ⬂ is the hard man of plastic. It offers one of the highest impact resistances compared with any other plastic. It is many times stronger than glass and for this reason is used heavily in the glazing industry. However, like any hard man it has its weaknesses. There are certain combinations of environments, temperature and stress that can adversely affect it. When it is attacked by certain organic chemicals it can be susceptible to cracking.

Once you have taken this into account there are many additives that can be used to bolster its reputation and uses. Polycarbonate is available in a wide range of grades, such as UV stable, high-flow, glass-reinforced, flame resistant, water resistant, lubricity, high-optical clarity and wear resistant. Depending on the production method used — injection moulded, extruded, blow moulded or foamed — polycarbonate will have different properties, each process requiring a different grade. Kartell ⬂ has used the plastic in a range of domestic products where strength is a critical factor.

La Mairie
Client: Kartell
Designer: Philippe Starck
Launched: 1999

Tough and clear

Dimensions	50 x 87.5 x 52.5cm
Production	**Injection moulded**
Material Properties	**Outstanding impact resistance**
	Excellent optical clarity; Flame resistant
	Excellent dimensional stability
	even at high temperatures; Durable; Non-toxic
	Excellent range of colours; Easy to process
	Good heat resistance up to 125°C; UV stable
	Available as transparent, translucent and opaque
	Recyclable (post-industrial and post-consumer)
Further Information	**www.exatec.de**
Typical Uses	**Safety helmets; eyewear; architectural glazing; compact discs and DVDs; kitchen containers; packaging; computer housings; automotive; mobile phone housings; visors**

more: Polycarbonate 028, 077, 097; Kartell 024–025, 028–030, 066

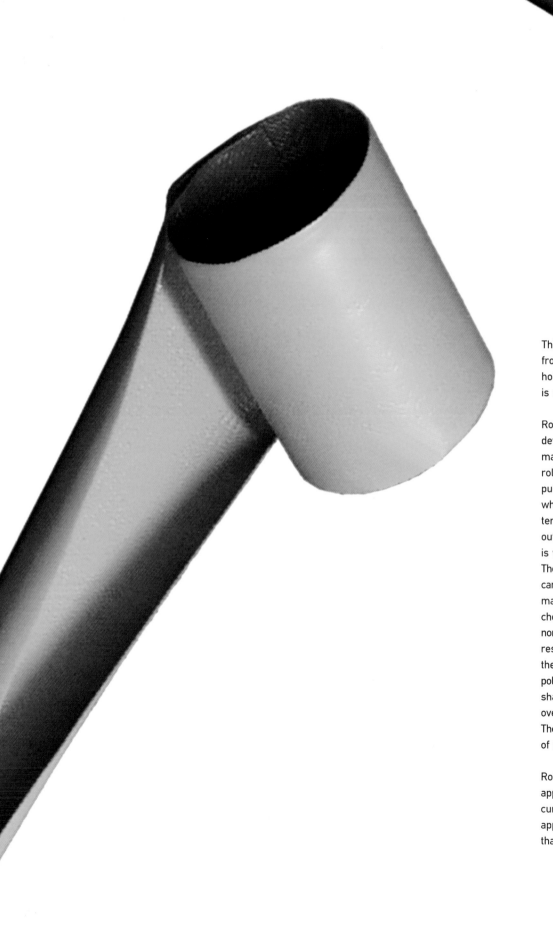

Think of a metal tape measure. When you pull it from its casing it transforms from being flat to holding a rigid shape. However, a tape measure is nothing compared to this material.

Rolatube™ is a UK-based company that has developed and patented a Bi-stable composite ↘ material that transforms from a flat strip in its rolled-up coil state, to tubular forms when it is pulled from its coil. Unlike the tape measure, which relies on the casing to contain the inherent tension, the Rolatube™ technology needs no outside force to hold it in either position, which is where the reference to Bi-stable comes in. The material is made from glass ↘, aramid ↘ or carbon ↘ fibres held within a thermoplastic ↘ matrix such as polypropylene or Nylon ↘. The choice of polymer is dictated by the end use — normally temperature conditions and chemical resistance — and has no affect on the ability of the product to bend. Colour can be added to the polymer when required. Typically the formed shapes are tubes, which can be open or overlapped, or created to be less enclosed. These shapes can be rolled and unrolled thousands of times without any loss of performance.

Rolatube™ currently have three main engineering applications for their technology, but research is currently looking into how the technology could be applied to more domestic consumer products that explore this compulsively playful invention.

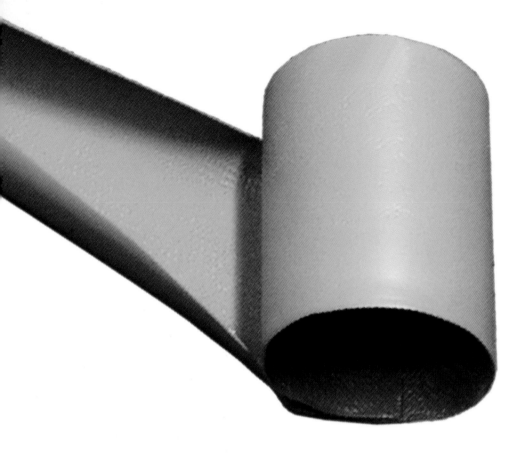

Flat to three dimensional

Dimensions	**Tube diameters: 2–140mm**
Production	**Laminated structure formed by using heat and pressure**
Material Properties	**Stable structure; Portable**
	High cycle life
	High strength-to-weight ratio; Bi-stable
	Easy to store; Easy to access
	Cost effective in terms of storage, transportation
Further Information	**www.rolatube.com**
Typical Uses	**Temporary communications masts, or struts which can be rolled in or out many times; permanently installed structures such as pipes which need to be easily transported and stored; machines for deploying cameras; tools for remote operation in hazardous environments**

more: Composite 030, 055, 082, 087, 108–109, 116; Glass Fibre 027, 072, 082, 087, 091, 109, 127; Aramid Fibre 082, 087; Carbon Fibre 030, 082, 087; Nylon 034, 067, 091, 093, 098, 118

↑

103 Recycled

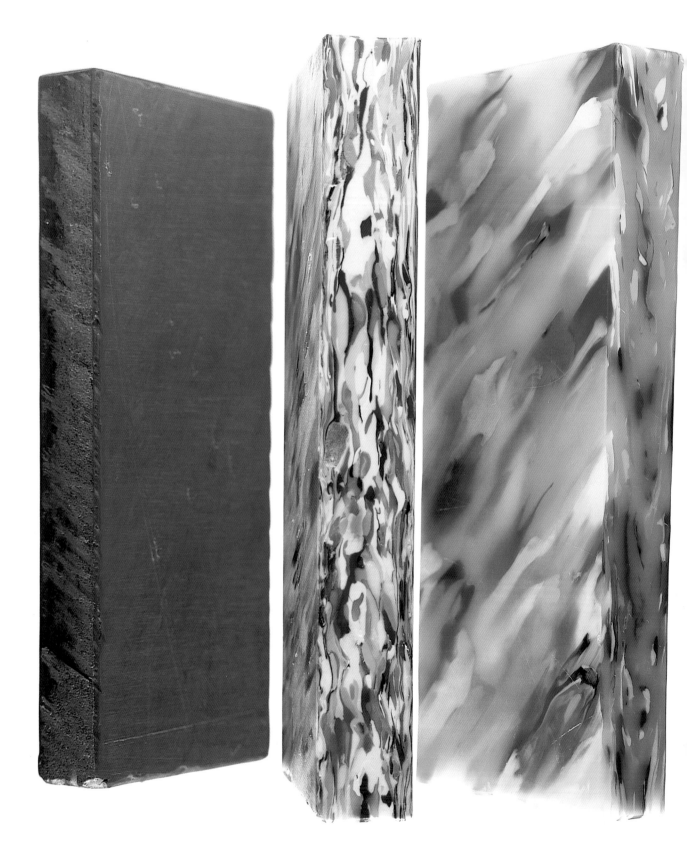

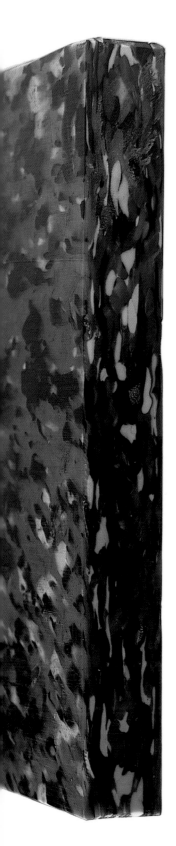

Dimensions	2 x 1m; various thicknesses
Production	Fabricated from post-consumer waste
Material Properties	Distinct visual appearance; Easy to process
	No tooling investment; Recycled
	Available in a range of thicknesses
Further Information	Smile@aol.com
Typical Uses	Furniture; interiors; work surfaces

Client: Smile Plastics
Designer: Colin Willamson
Launched: 1995

Rubbish!

The growing awareness of waste management has produced many innovative ways of recycling waste into new products and materials. Much of our waste is packaging related. After use it is thrown into our dustbins and transported to expensive landfill sites or incinerators.

Smile Plastics is one of many companies across the world committed to sourcing and developing innovative ideas and markets for recycled materials, concentrating on transforming plastics into multicoloured sheets. What separates these sheets from other post-waste products are the layers of disgarded shampoo bottles, wellington boots and yoghurt pots, which can be seen in the surface. This process produces sheets of plastic material, which unlike other plastic sheets are not all identical. The original waste is collected, sorted, flaked and thoroughly washed to remove any remaining contaminants. Looking like multicoloured cornflakes the pieces are then compressed into sheets by a process of heat and pressure, which retains the colours of the original bottles. These sheets can be sawn, drilled, routed and planed using conventional workshop tools. The surface requires no treatment, not even a sealant. Each product has a unique tactile feel from waxy to rubbery.

more: Polyethylene 14–16, 034, 038, 053, 107, 113, 116, 125

No residue

You will need:
- Polyethylene resin
- A pinch of additive
- Extruding machine
- Some organic rubbish from your kitchen/garden

What to do:
- Take a large container and mix together the polyethylene resin ↘ and a low dose of additives.
- Place the mix in your film-extruding machine, and run off as many bags as you think you will need for the waste in your kitchen and garden. Separate the bags and fill with your garden refuse. Once you have filled your bags place them in a commercial compost heap (windrow system). After about three months the bag has vanished (apart from minute quantities of carbon dioxide and water) and you should have a heap of delicious compost.

Not only can this product totally degrade, but the time can be set for it to disappear as well. A unique property for a plastic bag, it can have a life for as long as you require it. So a carrier bag can be designed to last for two to five years, while other types of packaging can be made to last only a few months.

Symphony Environmental uses a technology known as EPIs®, TDPA™ (Totally Degradable Compostable Additive). This process uses a small percentage of the additive, which can be combined with polyethylene or polypropylene ↘ resins. The additive used does not affect the properties of the finished film. The degradation process, which is affected by light, heat and stress (pulling and tearing), begins as soon as the material goes into use. One of the best things about this process is that it can be controlled to adjust the length of time the plastic takes to degrade.

Production	**Extruded film**
Material Properties	**Fully degradable**
	Relatively low cost
	Good chemical resistance; Easy to process
	Polyethylenes are available in a number of
	physical grades (LDPE, HDPE, MDPE)
Manufacturer	**Symphony Environmental Ltd.**
Further Information	**www.symphonyplastics.co.uk**
	www.degradable.net
Typical Uses	**Packaging; refuse sacks; food produce bags;**
	swing bin and pedal bin liners; food freezer bags;
	carrier bags; dog-waste bags

more: Polyethylene 014–016, 034, 038, 053, 105, 113, 116, 125; Polypropylene 014–016, 025, 037, 045, 049, 061, 070, 083, 107, 109

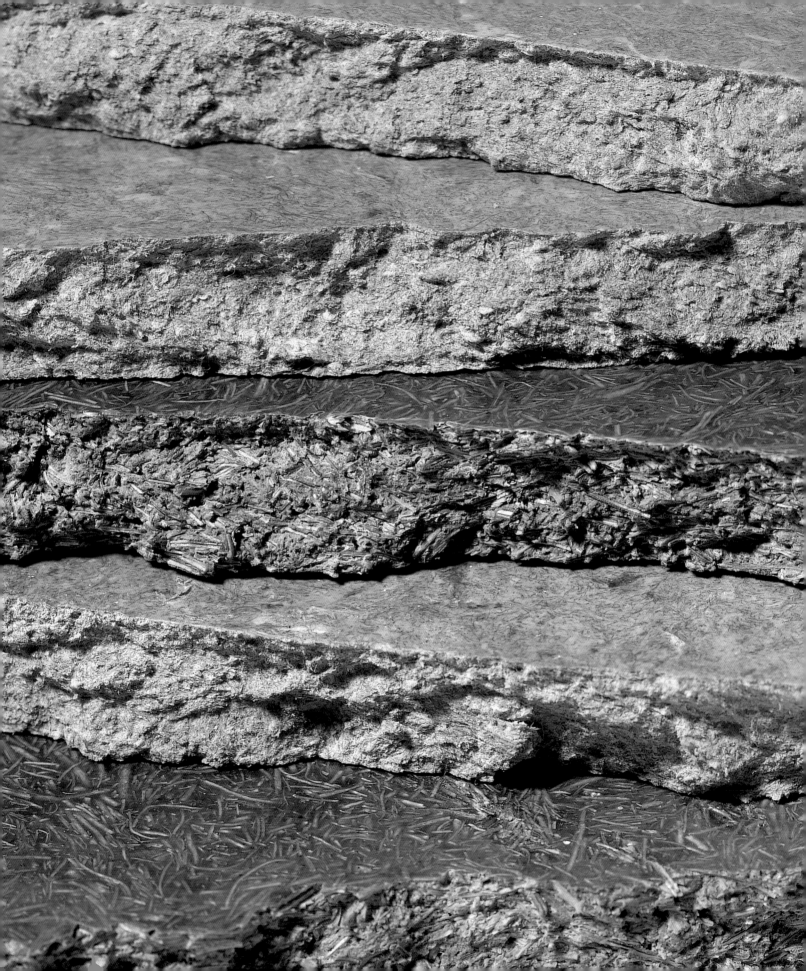

Like a recipe, plastic can also be used to combine with other materials to form new interesting composites. Old jeans, retired bank notes and coconut coir are some of the fillers used by Grot in their plastic recipes. The addition of these materials challenges notions of composites ↘ being high-tech like carbon or glass fibre.

Started in 1996 through research carried out at the USDA Forest Products Laboratory, Grot Global Resource Technology started to produce composite materials offering a natural alternative to virgin, recycled, mineral or glass-filled thermoplastics ↘. They produce a range of polymers, which allow for an assortment of natural fibres to be added to them. From this basis a range of products for a variety of applications can be made using different production methods, including extrusion, injection moulding, compression moulding and blow moulding.

The materials are made by melt-blending natural fibres with a range of thermoplastics. The physical and visual qualities of the final composite are determined by the natural fibre selected, for which Grot offer certain recommendations. If you are looking for a strong visual quality they recommend polypropylene ↘ mixed with either rice hulls, pine wood dust, coconut coir or sisal as the best combination. If it's tensile strength you're after they can recommend kenaf (mesta), jute, hemp, flax and Kraft wood fibre (not sawdust).

Old jeans

Material Properties	Natural appearance
	Low cost – less than the base resin
	Fully and easily recyclable; Easy to colour
	Reduced moulding cycle time, up to 30%
	Non-abrasive to machinery; Low mould shrinkage
	Low thermal expansion coefficient
	High tensile & flex modulus: up to 5 x base resin
	Lower processing energy requirements
Further Information	www.execpc.com/~grot/index.htm
Typical Uses	Automobile interiors; construction products; office products; furniture; storage containers; window and picture frames; food service trays; fan housings and blades; toys

more: Composite 030, 055, 082, 087, 100–101, 116; Thermoplastic 022, 027, 029, 071–072, 090, 100–101, 127; Polypropylene 014–015, 025, 037, 045, 049, 061, 070, 083, 107

Rags to riches

Textile designer Luisa Cervese uses many different materials in her fun and elegant handbags, totes and cushions. While she was working as a textile researcher for a major Italian textile company, Cervese noticed the amount of textile off-cuts that just got thrown away. This waste inspired her to start experimenting by combining textile waste with plastics of different properties. Using different types of plastic means that each batch of material requires a different form of manufacture thus leading to an array of different results and unique products.

Industry creates an enormous amount of waste, which is the basic element of Riedizioni pieces. The nature of Cervese's production process means that each piece is unique — it is almost as if the machine is a craftsman who 'chooses' the fabric's components each time.

Cervese's aim was to create a product that is simple yet unique and which involves the minimum possible amount of waste. The quality of the plastic is important but each plastic can be chosen to suit the final product. Silk polyurethane ⭢ can be rolled very thin and combines well with the waste to produce a material ideal for the bags and rain coats. Not only does it give the products their individuality but it also provides durability, waterproofing and structure.

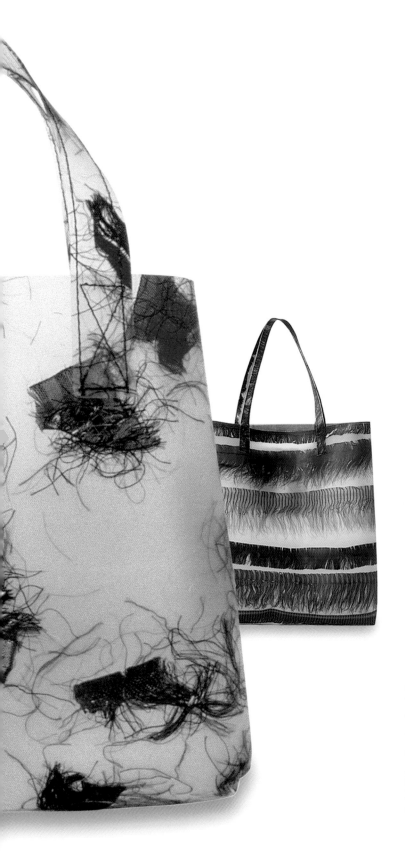

Riedizioni
Designer: Luisa Cervese
Launched: 1995

Material Properties	Low material costs
	Extremely durable
	Strong
	Highly flexible
	Good water resistance
Further Information	www.riedizioni.com
Typical Uses	Handbags; purses; clothing; placemats; cushions

Metamorphosis

Dimensions	**140 x 8mm**
Production	**Injection moulded**
Material Properties	**Made from recycled material; Low cost**
	Requires less energy to convert the material
	than to use virgin polystyrene
	High visible appeal for the benefits of recycling
Further Information	**Remarkable Pencils**
	www.save-a-cup.co.uk, www.re-markable.com
Typical Uses	**Stationery; video cassettes; office equipment**

more: Polyethylene 014–016, 034, 038, 053, 105, 107, 116, 125; Polystyrene 075, 121

The Save-a-Cup scheme was established as a non-profit company by vending, foodservice and plastics industries to collect the millions of vending cups thrown away in the UK every week. The use of a single material in the initial production and the captive environment in which they are used allows for easy collection.

Participating organisations use special collectors, designed to condense up to 480 cups, with a facility to pour off any liquid. The cups are discharged into polyethylene ➘ sacks for regular collection by a Save-a-Cup vehicle for delivery to the reprocessing operation.

During reprocessing, contaminants are removed before the material is converted into dry flakes, or further processed into pellets suitable for wide-ranging applications. With more than one billion cups collected so far for recycling, the company's objective is to collect 750 million used cups per year by 2001.

Remarkable is dedicated to giving second life to the thousands of tonnes of waste produced every day in the UK. As well as plastic cups they also produce products from food and drinks containers, paper and car tyres. The unique Millenium Pencils are each made from one recycled polystyrene ➘ vending cup.

Millennium Pencil
Designers: Remarkable Pencils
Launched: 1994

115 Familiar

The design and production of many sporting products have used the science of materials to their fullest: TPEs ⬊ for diving fins, composites ⬊ in racket sports, aminos in bowls. The intelligent dimpled surface of a golf ball is designed to affect its flight and height when it is propelled at 150mph down the fairway. Dunlop has three patterns in their range and they are of such importance they are looked after by a golf ball Dimple Development Manager.

Originally made of feathers wrapped in a leather skin, the outer skin of modern golf balls is made from a high-impact, cut-resistant polyethylene ⬊. Anyone who has ever dissected a golf ball will know that behind the skin you will often find a tight bundle of elastic bands, over which the polyethylene is injection moulded. The core is held in place in the mould by pins which are retracted just before the process is complete. The seam is then cut and sanded off, followed by a coat of varnish.

Dimensions	Diameter 41mm
Production	Injection moulded Surlyn® cover
Material Properties	High melt strength
	Outstanding impact toughness
	Abrasion resistant; Scuff resistant
	Chemical resistant
	Good transparency and clarity
	Direct adhesion to metal, glass,
	and natural fibres by heat lamination
	Direct adhesion of epoxy and polyurethane finishes
Further Information	www.dupont.com/industrial-polymers/surlyn
Typical Uses	Door handles; toys; hockey helmets;
	perfume bottles; footwear; body boards;
	ten-pin bowling pins; tool handles

Tough skin

Maxfli
Client: Dunlop
Designer: Dunlop Slazenger
International R&D Team
Evolved through the 1980s

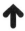

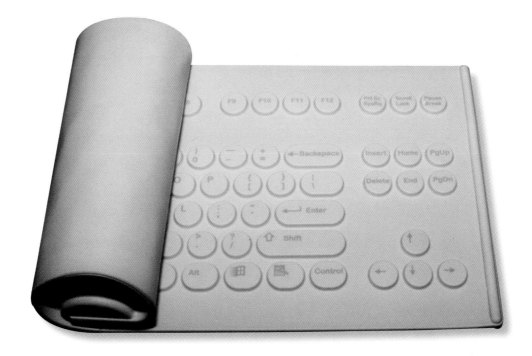

Flexboard
Designer: Man and Machine Inc.
Launched: 2000

A new gesture

Dimensions	**499 x 175 x 7mm; weight 700g**
Production	**Cast polyurethane**
Material Properties	**Excellent tear strength; Good chemical resistance**
	Outstanding flex life, cut and scratch resistance
	Flexible; High elasticity; Good colour range
	Wide range of physical forms and
	mechanical properties
Further Information	**www.mmits.com**
Typical Uses	**Sheeting; car bumpers; bladders; fuel line tubing;**
	packaging material; car body mouldings

It's soft and flexible, and it bends and twists like rubber. The Flexboard is manufactured from polyurethane foam ◤, a material first marketed in 1941, and ideal for this application because of its oil and solvent resistance. It can also be cast in a mould. Keys are laser-etched to save the cost of retooling for different languages. The keyboard stays flexible due to a series of rigid pieces of printed circuit board rather than a flexible PCB.

Since it can be manufactured either in rigid or flexible form, polyurethane caters for a wide field of applications. Soft-foamed polyurethane is used for cushions, mattresses and trims. Hard polyurethane is employed in the automotive, construction and furniture industries, where it is highly valued as a material with exceptionally good thermal and acoustic insulation properties.

more: Polyurethane 019, 022, 026, 030, 039, 072, 078, 085, 111, 120

Takes the knocks

Dimensions	Diameter 216mm
Production	Cast polyester resin
Material Properties	Good impact strength; Excellent hardness;
	Good surface finish; Good stiffness
	Excellent dimensional stability
	Low friction; Excellent resistance to chemicals
	Recyclable (PET is one of the most recycled plastic resins)
Further Information	www.columbia300.com
Typical Uses	Soft drink bottles; food packaging

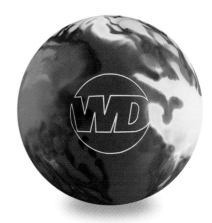

The idea of throwing a ball across the ground and trying to make it hit something else has been in existence since the Ancient Egyptians. Modern bowling began at the beginning of the 19th century with balls originally made from the hardwood lignum vitae until the 1960s when polyester became an ideal replacement.

There are many functions that these bowling balls needed to satisfy above being hard-wearing. The bowling alley is a demanding environment with balls weighing from 8lb to 16lb and the industry dictating that all balls should have a consistant Shore hardness ⩗ of 73. Each ball contains a variety of fillers for the different weights, from heamatite for heavy density to glass micro balloons for the lighter balls. The cores are then cast in polyester resin ⩗ within a steel mould from which they emerge with a rough surface. These are then turned and ground into a sphere. Holes are drilled according to the user's grip after purchase.

PETs ⩗ are one of two main polyesters – the other being polybutylene terephthalate (PBT) – that compete with Nylons ⩗. As well as being used in the textile industry their other main and most common household application is in carbonated drink bottles.

With continual hitting speeds of 14mph the pins need to withstand constant knocking, which they manage by having a wooden core coated with polyethylene resin.

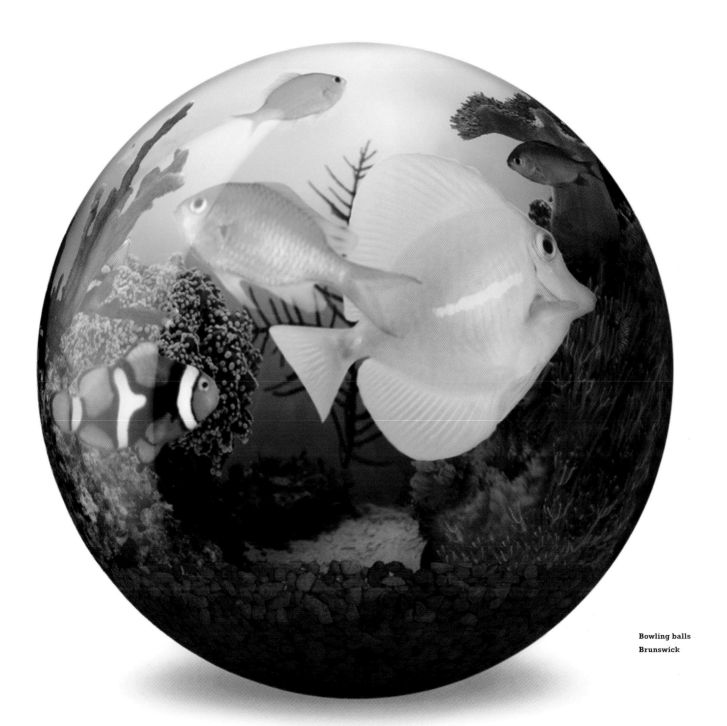

Bowling balls
Brunswick

more: Shore Hardness 072, 090, 127, 150; Polyester Resin 120; PET 079; Nylon 034, 067, 091, 093, 098, 100

Production	Cast, ground and polished polyurethane foam
Material Properties	High impact resistance; Scratch resistant
	Very high gloss; Easy to colour
	Excellent resistance to chemicals
	Heat resistant; Odour free
	Stain resistant; Fire resistant
	Good electrical insulation
	Limited production methods
Further Information	www.perstorp.com
Typical Uses	Handles; fan housings; circuit breakers; coat buttons; dinnerware; plastic laminates; ashtrays

A beautiful surface

Like the bowling ball ⬊, the billiard ball is definitely a product that needs high-impact resistance. For a speed of 0 to over 30km/h in less than one second, and a friction temperature of 250°C, it has to be made from a hard material. It has to be scratch resistant and resistant to chipping. The longer it holds its shiny surface the better the play and the less harm it can do to your baize.

Billiard balls are generally made from either melamine or polyester resin ⬊. Melamine resins ⬊ were the first synthetic plastics to be used in mass production, and due to their excellent electrical insulation properties have been used in housing for electrical products. With similar properties to phenolic resins ⬊ they are more appropriate for billiard and bowling balls due to their ability to easily absorb bright-coloured dyes.

The production of these simple spheres is based on a secret manufacturing process that has 13 steps and lasts 23 days. Constant density of material and colour reproduction need to be maintained in order to keep each ball exactly the same.

Aramith billiard ball

Good value

Dimensions	**From 5mm to 300mm**
Production	**Injection-moulded high-impact polystyrene**
Material Properties	**Low cost; Low shrinkage rate**
	Easy to mould and process; Easy to colour
	Good transparency; Excellent adhesion
	Very low water moisture absorption
	High melt flow; Non-toxic
	Good dimensional stability; Recyclable
Further Information	**www.huntsman.com, www.atofina.com**
Typical Uses	**Fridge compartments; food packaging;**
	audio equipment; coat hangers

Everyone who has ever made an Airfix model is familiar with this particular plastic. The glue ↘ virtually welds two pieces of plastic together. Those intricate details were so precise you could see the smile on the aircraft pilot's face. The snap of each piece coming away from the runners not only gave you fun in assembling the model but in its initial disassembly. The whole box was an illustration of a method of plastic production. Originally developed in 1939 by Nicholas Kove as a promotional tool for Fergasen the first Airfix self-assembly model was produced in 1949.

Today the company produces 240 models made in runs from 3000 units/year for the expensive 50 sets to 20,000 units for the smaller models, each model taking approximately 20 seconds to make. The use of high-impact polystyrene ↘ provides a balance between cost of materials such as ABS ↘, which can just as easily be injection moulded and a material which can give the high definition needed in the intricate details of the parts. It has a stiff structure with relatively thin wall thicknesses and good adhesion allowing easy glueing and painting.

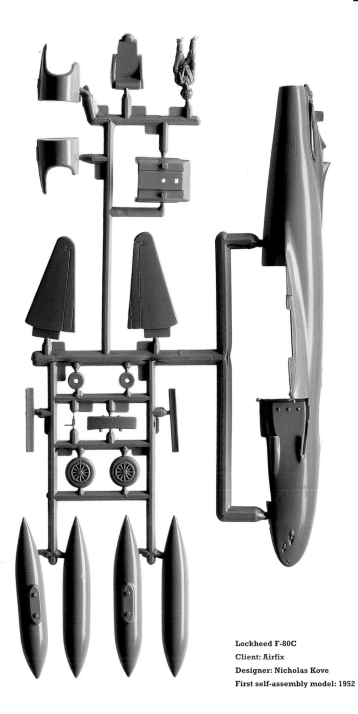

Lockheed F-80C
Client: Airfix
Designer: Nicholas Kove
First self-assembly model: 1952

more: Glue 053, 063, 085, 123; Polystyrene 075, 112; ABS 027, 060, 071, 075, 077, 097

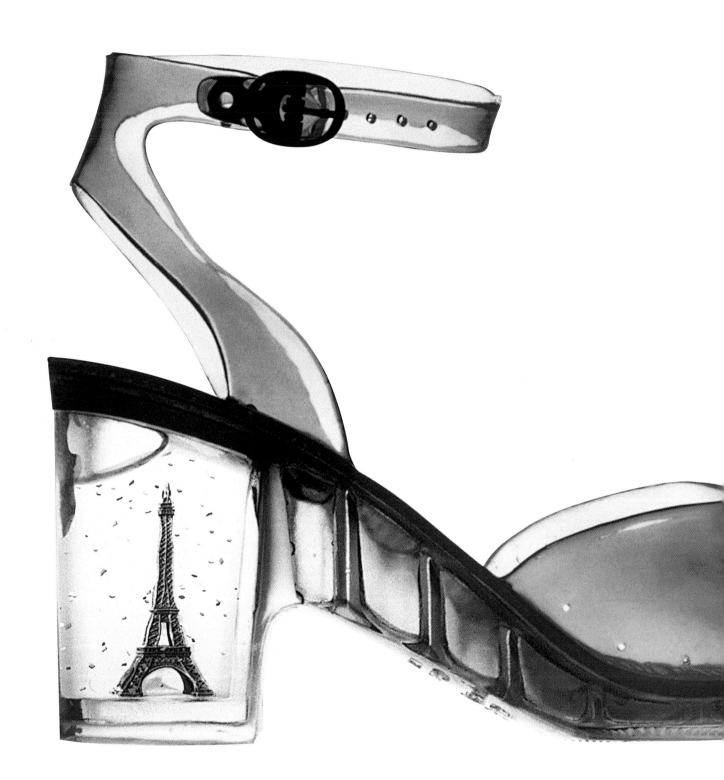

New form

Dimensions	**Size 6: 210 x 80mm**
Production	**Injection-moulded PVC**
Material Properties	**Versatile; Easy to colour; Cost effective**
	Additives can give it a large range of properties
	Good resistance to chemicals; Easy to process
	Good corrosion and stain resistance
	Excellent outdoor performance; Good rigidity
Further Information	**www.grendene.co.br**
Typical Uses	**Packaging; dip moulding; drain pipes; rain coats;**
	domestic appliances; credit cards; car interiors

Eiffel Tower Jelly
Designer: Patrick Cox
Launched: 1996

Enough shoes are produced by this Brazilian manufacturer in one year that they could supply Jelly shoes to half the entire Brazilian population of 160 million people. 'Jelly' is the perfect description for these products. As for Ping-Pong balls the qualities of the material have provided a name. Unlike Technogel®, which feels like Jelly, these shoes utilise the moulding and colour potential of plastics to create a new visual language for footwear. These objects are fascinating in their own right. The visible structure that provides a series of translucent windows is a great example of the mundane and everyday function of a pair of shoes made visible and highly decorative.

Although PVC ↘ is not the hardest wearing of materials it is a good compromise between strength, softness and cost. Each shoe is expected to last 2–3 years with regular use.

The shoes are generally moulded in two parts. In the case of the Eiffel Tower Jelly, the heel and sole are made from a single moulding with the upper part glued separately. The heel is usually made from a harder grade of PVC and the upper from a softer grade. The water is then injected into the heal with a syringe. To stop the water from going green it is treated with an anti-bacterial agent. The hole is then sealed up.

more: PVC 024, 035, 038–039, 047, 050–051, 058–059, 063, 065, 084, 092

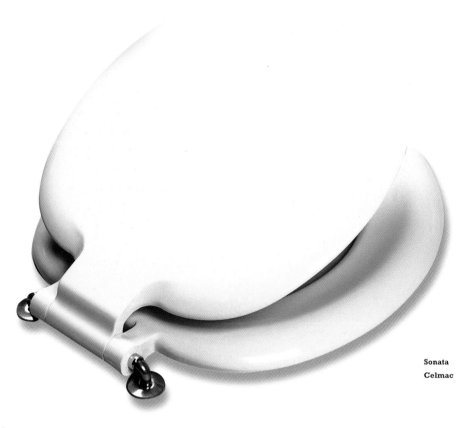

Sonata
Celmac

Urea is defined in the dictionary as 'a substance found in mammalian urine' so what a perfect match of material with function that it should be used as a toilet seat. As a thermoset material it was one of the first materials to give Bakelite the shoulder because unlike Bakelite ↘ it could be moulded and produced in any colour. Produced by heating urea and formaldehyde ↘ and in production since the late 1930s it belongs to the family of organic polymers.

Because of its heavy weight and general feel it has a high perceived value. When measured against melamine ↘ compounds it has similar properties but without the high cost. As a moulding compound it can be compression or injection moulded to produce a range of products. As a resin it is used for laminates, and binders for chipboard and plywood. As a foam it is used as insulation in wall cavities.

Close to the skin

Dimensions	445 x 387mm
Production	Compression moulded
Material Properties	Good chemical resistance; Easy to colour
	Warm; Good electrical insulation
	Scratch resistant; Stain resistant; High-gloss finish
	Cost-effective compared to melamine
Further Information	www.perstorp.com, www.polypipe.com/bk
Typical Uses	Electrical switch plates; junction boxes;
	toilet seats; toilet seat covers; caps and closures
	for perfume bottles; buttons

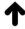

Everybody knows that reassuring slippery, soft plastic and that satisfying feeling as you seal down the lid ready for a picnic. That sound even has a name, the 'Tupperware burp', redefined in the 1970s as the 'whisper'. Not since the Ping-Pong ball has the feel and touch of plastic been so iconaclised.

ICI first developed polyethylene ↘ in 1939, but it was a chemist at DuPont that first discovered how to injection-mould it three years later. Soon after he set up Tupper Plastics ↘. Although they were originally distributed in shops it was not until Brownie Wise, the first door-to-door Tupperware lady took them to the homes of American women that the products really took off. Eventually sales from shops were withdrawn due to low sales. Today it is estimated that somewhere in the world a Tupperware party is taking place every 2.5 seconds.

Production	**Injection-moulded polyethylene**
Material Properties	**Lightweight; Unbreakable**
	Relatively low cost
	Good resistance to hot and cold temperatures
	Excellent resistance to chemicals
	Well balanced relationship between stiffness, impact strength and resistance to environmental cracking
	Crack-resistant; Hygienic; Recyclable
Further Information	**www.tupperware.com, www.basell.com**
	www.dsm.com, www.dow.com
Typical Uses	**Chemical drums; carrier bags; car fuel tanks; blow-moulded toys; cable insulation; furniture; wire insulation**

Burp

Wondelier bowl set
Tupperware
Designer: Earl C. Tupper
Launched: 1949

more: Polyethylene 014–016, 034, 038, 053, 105, 107, 113, 116; Tupperware 015

Celebrity status

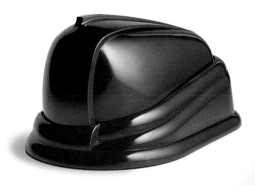

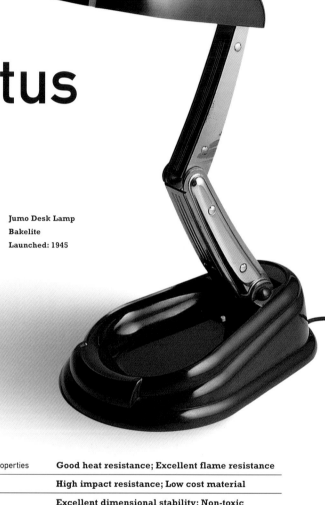

Jumo Desk Lamp
Bakelite
Launched: 1945

Bakelite ↘ was declared 'the material of a 1000 uses', when it was discovered in the first part of the 20th century. The promotion of Bakelite went hand in hand with the emergence of the new profession of industrial designers. Raymond Loewy was often seen in Bakelite advertisements singing the praises of the new plastic material. It was one of the first plastics that gave designers freedom to create new aesthetics for products.

The name Bakelite is also the name of a company that produces phenolics and other materials. Phenolic resin ↘ does not work well with the addition of colours which is why phenolics are generally dark colours. Today phenolics are largely used as binders or adhesives in the production of board material and laminates ↘. As a moulding compound it can easily be reinforced by fillers and fibres that offer strength and prevent the product being too brittle. One of its few modern-day uses is as handles for cookware.

Material Properties	Good heat resistance; Excellent flame resistance
	High impact resistance; Low cost material
	Excellent dimensional stability; Non-toxic
	Good hardness and scratch resistance
	Outstanding electrical insulation
	Best suited to dark colours
	Brittle if moulded in thin wall thickness
	Hard as a solid component
Further Information	www.bakelite.de, www.bakelite.ag
Typical Uses	Brake linings; oasis foam support for flowers; binding for laminated wood panels; bowling bowls; saucepan handles; door handles.

Supremecorq®
Client: Supremecorq®
Launched: 1992

Self-sealing

Dimensions	**Diameter 45mm or 38mm**
Material Properties	**Flexible; Good resistance to oil and chemicals**
	Good resistance to tearing and abrasion
	Easy to colour; Recyclable; Can be painted
	Available in a range of Shore hardnesses ⭨
	Can be extruded, injection moulded
	and blow moulded
	Keeps its properties at low temperatures
	Can be reinforced with glass fibre
Further Information	**www.aestpe.com, www.supremecorq.com**
Typical Uses	**Automotive, mechanical engineering;**
	watch straps; sports shoes; shock absorbers;
	side trims for cars; hand tools; ski boots;
	offshore cabling; vacuum cleaner hoses;
	tyres for shopping trolleys; grips for hand tools

From Bordeaux to the Napa Valley and from Italy to Australia wineries are turning away from natural cork in favour of plastic wine stoppers. The use of plastic corks was introduced to counter the occurrence of 'corked' wine, when the wine has a mustiness and bad taste. More and more supermarkets are insisting on consistent quality forcing vineyards to use plastic cork.

Made from a thermoplastic elastomer ⭨, used for its elastic sealing properties, the corks have a warm, slightly porous feel. This provides the sufficient leak and evaporation sealing qualities needed. The distinctive marbled effect results from the injection-moulding process cooling at different rates. The corks have a self-sealing property, so when your corkscrew comes out of the cork the hole virtually seals up.

more: **Elastomer 038, 071–072, 083, 086, 090–091, 097; Shore Hardness 072, 090, 118, 150**

129 Side Dishes

If ever a plastic was fun to play with as a child this was one of them. Usually applied to t-shirts and spoons, you hold it for a couple of minutes in your sweaty palms over radiators and under taps and it changes colour.

There are many types of colour-changing technologies; Thermochromic (changing colour with temperature) and Photochromic (changing colour with ultraviolet light) are probably two of the most widely used. They can be applied as inks or as an impregnation into the material.

Thermochromic (TC) applications consist of two kinds of technologies: liquid crystal and leuco dyes. For applications where a high degree of accuracy is required liquid crystal technology can give a greater control when regulating temperatures, which can usually be measured between -25°F to 250°F and can be sensitive enough to detect a change of 0.2°F. They start black and change to milky brown, red, yellow, green, blue, violet and black if the temperature goes above its range. Leuco dyes offer less accuracy and are a cheaper alternative than liquid crystals. Photochromics (PCs) change colour in response to ultraviolet light, and are most commonly found in sunglasses.

Material Properties	Can be printed; Offers high visual appeal
	Adheres to a variety of substrates
	Can offer good safety potential
	Cost effective; Exciting appeal
	Advanced technology for a wide range of specifications
Further Information	www.colorchange.com/company.htm
	www.interactivecolors.com
	www.solaractiveintl.com
Typical Uses	Thermometers; novelty products; baby products; mood rings; battery testers; toys; sunglasses; packaging for batteries

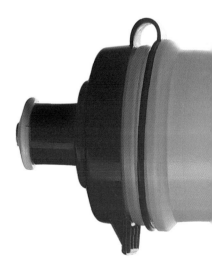

Colour and heat

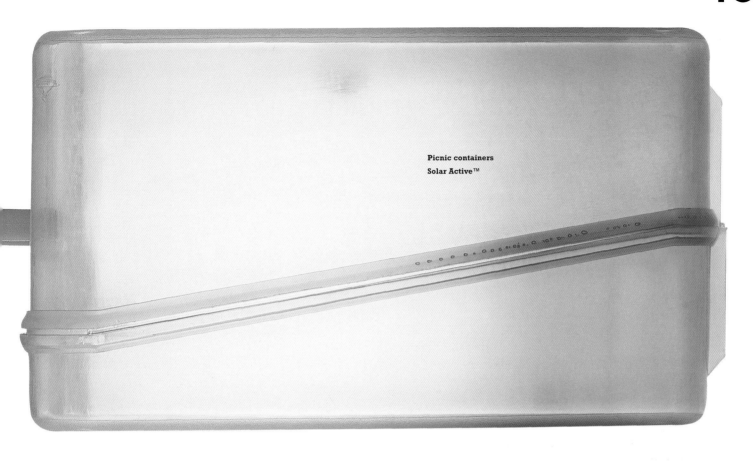

Picnic containers
Solar Active™

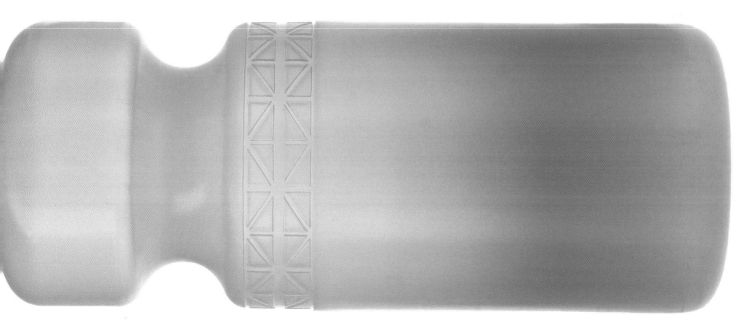

Material Properties	**Can offer high perceived value**
	Available in a range of metallic colours
	Looks like metal but can be produced in forms
	that could not normally be made in metal
	Does not chip; Cost-effective
	Contained in the plastic rather than sprayed on
	Avoids costly additional painting
	Environmentally better as no paint necessary
Further Information	**www.geplastics.com/resins/visualfx/index.htm**
Typical Uses	**Moulded parts which can be made from a large**
	number of polymers

Faking it

The seduction of products is as much to do with form and function as it is to do with the tactile and visual qualities of the surface. Industrial designers in the 1930s used Bakelite ⌲ for its ability to mould itself into any shape they conceived. Today's products command our attention not just through their material but through their surface finishes.

Manufacturers are always looking for intelligent finishes that challenge our preconceptions. The paint finish Nextel was in vogue for a while from the late 1980s until we tired of it chipping off the corners of our hi-fis. Alas no more, plastics can now be made with effects built into the plastic so paint is no longer necessary.

DuPont have created a range of special-effect polymers that recreate the surfaces and finishes of other materials. One of these products is Ares which is supposed to 'simulate the look of metal more realistically than previously possible'. The effect is created by adding smaller-than-human-eye-sized metal flakes into the resins before processing. The resulting effect creates a greater sense of depth in the surface than paint would be able to achieve. It also doesn't chip.

Other effects in the DuPont stable include 'Light diffusion', a material that creates a translucent effect giving a sense of 'depth and mystery'. 'Energy' is a fluorescent resin available in a range of striking colours with different opacities. 'Marble' speaks for itself and the subtle change of colour in 'Intrigue' gives a transient two-tone effect when the viewer moves in relation to the object.

more: Bakelite 061, 066, 124, 126

135 Appendices

Processing plastics

Any discussion about the use of plastics in products cannot ignore the manufacturing techniques that are used to process them. Many plastics can be produced by many of the processes. Choosing the right production process depends on many criteria: the shape of the product, the material requirements, the amount you can invest in tooling and the number of parts you want to make. Injection moulding requires high tooling investment but offers cheap unit costs, compared with rotational moulding which has lower tooling costs but high unit prices.

Here you will find some of the major processing techniques.

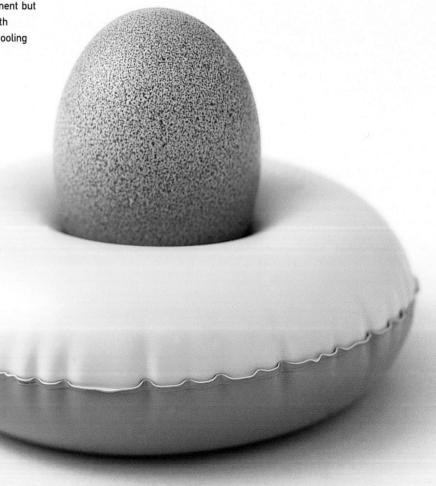

Blow moulding	A production process often featured on children's TV shows when they want to talk about mass-production. Images are shown of tubes of plastic blown into a mould which are then sent running around a conveyor belt circuit. This process takes two forms: injection blow moulding and extrusion blow moulding.
	Most plastic drink containers use the injection blow moulding manufacturing process. The process literally is like blowing a balloon of plastic into a shape, which is determined by the inside shape of the mould. The use of injection moulding allows for details like threads to be formed, which will allow for the fitting of a lid.
	In injection blow moulding the process involves two stages. First a tube is injection moulded. This will normally include a thread for a lid, which is then rotated to the blow moulding tool where hot air is injected into the tube. There it expands to fill the cavity of the final mould. Any textures and surfaces can be formed on the mould cavity and pressed on to the final part.
	Extrusion blow moulding is a similar process, but instead of the part being injection moulded at the beginning, it is extruded as a tube and pinched at both ends and then blown up to fill the mould.
Typical Uses	Milk bottles, fizzy drinks bottles and containers

Calendering	The process of forming thin sheet material from plastic. It is the usual starting point for thermoforming sheets for shower curtains and cling film. Calendering involves plastic pellets being fed through a series of heated rollers to form a sheet or film. Textures can be embossed into the sheet by texturing the rollers.
Typical Uses	Acetate sheet, PVC sheet, shower curtains and table cloths

Extrusion

The best way to understand extrusion is to think of the plastercine toys for children, where you put the plasticine in a tub, turn the handle, and long, continuous lengths of the same shape are produced. This effectively is the same process as that used for modern mass-produced extrusions.

The plastic pellets are poured into a hopper where they are heated and mixed with additives. A screw carries the melted plastic through the shaped die to produce continuous lengths of shapes with the same profile, which are then cooled by air or water.

Extrusion is also used in metal parts and as with plastic, sheets are cut to their desired length. Window frames, tubes, sheet and film are all typical examples of the extruding process. Cost compared to injection moulding is quite low. However, production is generally limited to minimum-order lengths.

Typical Uses

Profiles, pipes, films, paper binders, window frames, Australian dollars and curtain rails

Compression moulding

Compression moulding is used primarily for solid parts using thermosetting plastics. Compared with injection moulding, extrusion and other high turn-around production methods, compression moulding is slower and more labour intensive but has the advantage of lower tooling costs.

A measured amount of powdered resin is added to a two-part mould and the action of heat and pressure when the two moulds are brought together cures the material. Good surface detail can be achieved with this process, but each piece will usually require some hand finishing.

Typical Uses

Melamine plates and toilet seats

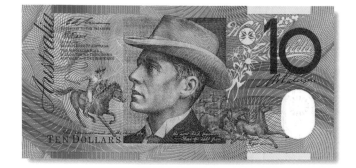

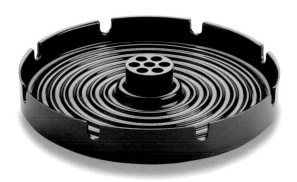

Casting	Although with limited use in mass production, casting is one of the easiest and most accessible ways of producing simple solid plastic parts. Most hobby or craft shops will sell the basic moulding and casting materials for this process to be completed at home.
	Parts are initially made from any material, which can be cast to create a female mould. This mould will then be used to form the final part. Generally casting materials are acrylic, epoxy, phenolic, polyester and polyurethane resins. Moulds can be created in rigid or soft materials. Resins are usually cured by the addition of a catalyst, and colours, additives and fillers are added prior to casting.
Typical Uses	Paper weights, sheets and mouldings

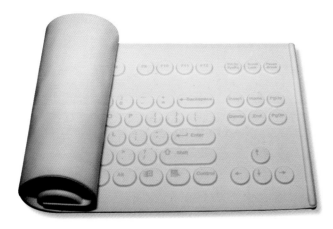

Rotational moulding	Rotational moulding is used to create hollow, usually large-scale products. Its relatively low tooling costs make it an ideal process for low production-run pieces.
	Precise quantities of powder or liquid are loaded into a two-part mould. The amount of material used determines the wall thickness of the final product. The mould is passed through a heating chamber and rotated along two axis. The plastic inside the mould melts and the rotating motion allows for the plastic to cover the inside mould wall. The tool is cooled and the final product is released. The nature of this process means that the final part will have a uniform wall thickness. Because there is no pressure involved this process is not ideally suited to parts that require fine detailing. The outside surface will replicate the wall of the mould while the inside will have an inferior finish.
Typical Uses	Storage drums, children's toy vehicles and wheelie bins

Injection moulding	It allows designers virtually total freedom to create almost any imaginable form and it is found in all areas of plastic product manufacture. Initially limited only to thermoplastics injection moulding it can now also be used for thermosets.
	The process involves the polymer pellets being fed into the machine through a hopper and then into a heated barrel. The heat from the barrel turns the plastic into a liquid resin, which is then injected into the mould. Co-injection moulding involves the injecting of two colours or materials into the same mould to create two distinct finishes or colours.
	Injection moulding is a high-volume, high-tooling cost process, where parts are produced at a rapid rate. Tolerances and details can be highly controlled. Unit costs are relatively low but the process generally requires a much higher upfront tooling cost.
Typical Uses	Computer housings, Lego and plastic cutlery

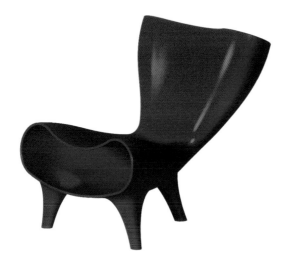

Thermoforming	**Thermoforming can be broken down into two main processes: vacuum forming and pressure forming. Both processes use pre-formed plastic sheet as the starting material. The principle of thermoforming relies on the use of either a vacuum or pressure to suck or push the plastic sheet over or into a mould.**
	In vacuum forming a mould is placed on a bed which can be lowered and raised. The plastic sheet is clamped above the mould and heated to the correct temperature at which point the mould is raised into the soft material and a vacuum is applied. The sheet is then sucked over the mould.
	The process of vacuum forming offers cost effectiveness over many other plastic forming processes in the initial tooling investment. Because of the low pressure that is required, moulds can be made from aluminium, wood or even plaster. The accessibility of this process has meant that it is standard workshop equipment in most art and design workshops, where one-off experiments can be made.
	Pressure forming requires a higher pressure than vacuum forming. Instead of a vacuum being used to pull the material over the mould, pressure is used to push it into either a male or female form. Pressure forming is better suited to products that require fine detail in the finishing.
Typical Uses	**Baths, boat hulls and take-away lunch boxes**

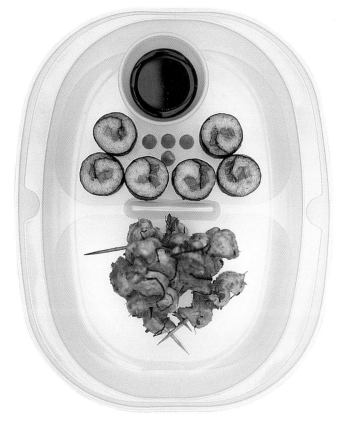

Injection Blow Moulding

screw fills mould

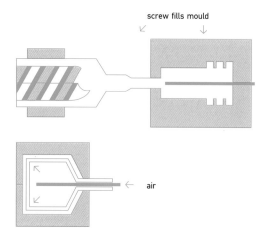

air

Extrusion Blow Moulding

hopper heater elements

electric motor

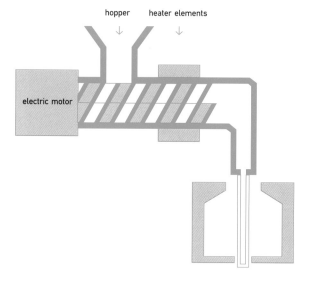

Extrusion

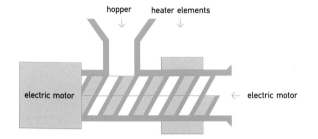

hopper heater elements

electric motor ← electric motor

Extrusion of Blow Film

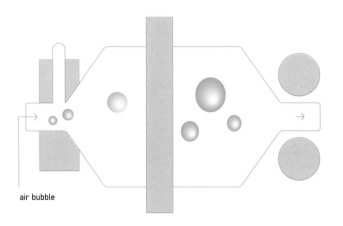

air bubble

Injection moulding

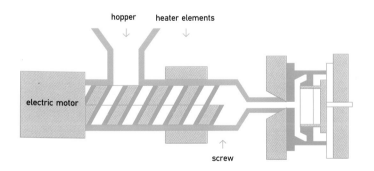

hopper heater elements

electric motor

screw

Thermoforming

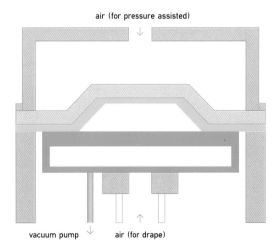

air (for pressure assisted)

vacuum pump air (for drape)

Technical Information

Name	Trade names	Applications	Properties
THERMOPLASTICS Acrylics **PMMA**	**Perspex** **Diakon** **Oroglas** **Plexiglas**	**Signs, inspection windows, tail light lenses, leaflet dispensers, lighting diffusers, hi-fi dust covers**	**Hard, rigid, glass-clear, glossy, weather resistant, excellent for thermoforming, casting and fabrication**
Acrylonitrile Butadiene Styrene ABS	Lustran Magnum Novodur Teluran Ronfalin	Telephone handsets, rigid luggage, domestic appliance housings (food mixers), electroplated parts, radiator grilles, handles, computer housings	Rigid, opaque, glossy, tough, good low temperature properties, good dimensional stability, easy to electroplate, low creep
Aramids	Kevlar®	Aerospace components, fibre reinforcement, high-temperature-resistance foams, chemical fibres and arc welding torches	Rigid, opaque, high strength, exceptional thermal and electrical properties (up to 480°C), resistant to ionising radiation, high cost
Cellulosics CA, CAB, CAP, CN	Dexel Tenite	Spectacle frames, toothbrushes, tool handles, transparent wrapping, metallised parts (reflectors etc.), pen barrels	Rigid, transparent, tough (even at low temperatures) low electrostatic pick up, easily moulded and relatively low cost
Ethylene Vinyl Acetate EVA	Evatane	Teats, handle grips, flexible tubing, record turntable mats, beer tubing, vacuum-cleaner hosing	Flexible (rubbery), transparent, good low temperature flexibility (-70°C), good chemical resistance, high friction coefficient
Fluoroplastics PTFE, FEP	Fluon Hostaflon Teflon	Non-stick coating, gaskets, packings, high and low temperature electrical and medical applications, laboratory equipment, pump parts, thread seal tape, bearings	Semi-rigid, translucent, exceptional low friction characteristics, superior chemical resistance, impervious to fungi or bacteria, high temperature stability (260°C), low temperature (-160°C), good weathering resistance and electrical properties
Nylons (Polyamides) PA	Rilsan Trogamid T Zytel® Ultramid Akulon	Gear wheels, zips, pressure tubing, synthetic fibres, bearings (particularly for food processing machinery) nuts and bolts, kitchen utensils, electrical connectors, combs, barrier chains	Rigid, translucent, tough, hard wearing, fatigue and creep resistant, resistant to fuels, oils, fats and most solvents, can be sterilised by steam

Block 1

Physical Properties			Producer	Resistance to Chemicals		Cost
Tensile modulas	2.9–3.3	N/mm^2	ICI	Dilute Acid	****	££
Notched impact strength	1.5–3.0	Kj/m^2	ICI	Dilute Alkalis	****	
Linear coefficient of expansion	60–90	x 10^6	Elf Atochem	Oils and Greases	****	
Max cont use temp	70–90	°C	Rohm	Aliphatic Hydrocarbons	**	
Specific gravity	1.19			Aromatic Hydrocarbons	*	
				Halogenated Hydrocarbons	*	
				Alcohols	****	

Block 2

Physical Properties			Producer	Resistance to Chemicals		Cost
Tensile modulas	1.8–2.9	N/mm^2	Bayer	Dilute Acid	****	£
Notched impact strength	12–30.	Kj/m^2	Dow	Dilute Alkalis	****	
Linear coefficient of expansion	70–90	x 10^6	Bayer	Oils and Greases	****	
Max cont use temp	80–95	°C	BASF	Aliphatic Hydrocarbons	**	
Specific gravity	1.04–1.07		DSM	Aromatic Hydrocarbons	*	
				Halogenated Hydrocarbons	*	
				Alcohols	*	

Block 3

Physical Properties			Producer	Resistance to Chemicals		Cost
Tensile modulas	n/a	N/mm^2	DuPont	Dilute Acid	n/a	£££
Notched impact strength	n/a	Kj/m^2		Dilute Alkalis	n/a	
Linear coefficient of expansion	n/a	x 10^6		Oils and Greases	n/a	
Max cont use temp	n/a	°C		Aliphatic Hydrocarbons	n/a	
Specific gravity	n/a			Aromatic Hydrocarbons	n/a	
				Halogenated Hydrocarbons	n/a	
				Alcohols		

Block 4

Physical Properties			Producer	Resistance to Chemicals		Cost
Tensile modulas	0.5–4.0	N/mm^2	Courtaulds	Dilute Acid	**	££
Notched impact strength	2.0–6.0	Kj/m^2	Eastman Chemical	Dilute Alkalis	*	
Linear coefficient of expansion	80–180	x 10^6		Oils and Greases	****	
Max cont use temp	45–70	°C		Aliphatic Hydrocarbons	****	
Specific gravity	1.15–1.35			Aromatic Hydrocarbons	*	
				Halogenated Hydrocarbons	*	

Block 5

Physical Properties			Producer	Resistance to Chemicals		Cost
Tensile modulas	0.05–0.2	N/mm^2	Elf Atochem	Dilute Acid	****	£
Notched impact strength	no break	Kj/m^2		Dilute Alkalis	****	
Linear coefficient of expansion	160–200	x 10^6		Oils and Greases	***	
Max cont use temp	55–65	°C		Aliphatic Hydrocarbons	****	
Specific gravity	0.926–0.950			Aromatic Hydrocarbons	*	
				Halogenated Hydrocarbons	*	
				Alcohols	****	

Block 6

Physical Properties			Producer	Resistance to Chemicals		Cost
Tensile modulas	0.35–0.7	N/mm^2	ICI	Dilute Acid	****	£££
Notched impact strength	13–no break	Kj/m^2	Ticoma	Dilute Alkalis	****	
Linear coefficient of expansion	120	x 10^6	DuPont	Oils and Greases	****	
Max cont use temp	205–250	°C		Aliphatic Hydrocarbons	****	
Specific gravity	2.14–2.19			Aromatic Hydrocarbons	****	
				Halogenated Hydrocarbons	* variable	
				Alcohols	****	

Block 7

Physical Properties			Producer	Resistance to Chemicals		Cost
Tensile modulas	2.0–3.4	N/mm^2	Elf Atochem	Dilute Acid	*	££
Notched impact strength	5.0–6.0	Kj/m^2	Vestolit	Dilute Alkalis	***	
Linear coefficient of expansion	70–110	x 10^6	DuPont	Oils and Greases	****	
Max cont use temp	80–120	°C	BASF	Aliphatic Hydrocarbons	****	
Specific gravity	1.13		DSM	Aromatic Hydrocarbons	****	
				Halogenated Hydrocarbons	*** variable	
				Alcohols	*	

KEY * poor ** moderate *** good **** very good

Name	Trade names	Applications	Properties
Polyacetals POM	Delrin® Kematal	Business mechanical parts, small pressure vessels, aerosol valves, coil formers, clock and watch parts, nuclear engineering components, plumbing systems, shoe components	Rigid, translucent, tough, spring-like qualities, good stress relaxation resistance, good wear and electrical properties, resistant to creep and organic solvents
Polycarbonate PC	Calibre Lexan Makrolon Xantar	Compact discs, riot shields, vandal-proof glazing, baby feeding bottles, safety helmets, headlamp lenses, capacitors	Rigid, transparent, outstanding impact resistance (to -150°C), good weather resistance, dimensional stability, dielectric properties, resistant to flame
Polyesters (Thermoplastic) PETP, PBT, PET	Beetle Melinar Rynite Mylar Arnite	Carbonated drink bottles, business mechanical parts, synthetic fibres, video and audio tape, microwave utensils	Rigid, clear, extremely tough, good creep and fatigue resistance, wide range temperature resistance (-40°C to 200°C), does not flow on heating
Polyethylene (High Density) HDPE	Hostalen Lacqtene Lupolen Rigidex Stamylan	Chemical drums, jerricans, toys, picnic ware, household and kitchenware, cable insulation, carrier bags, food wrapping material	Flexible, translucent/waxy, weatherproof, good low temperature toughness (to -60°C), easy to process using most methods, low cost, good chemical resistance
Polyethylene (Low Density) LDPE, LLDPE	BP Polyethylene Dowlex Eltex	Squeeze bottles, toys, carrier bags, high frequency insulation, chemical tank linings, heavy duty sacks, general packaging, gas and water pipes	Semi-rigid, translucent, very tough, weatherproof, good chemical resistance, low water absorption, easily processed using most methods, low cost
Stamylan PP PP	Hostalen Moplen Novolen Stamylan PP	Sterilisable hospital ware, ropes, car battery cases, chair shells, integral-moulded hinges, packaging films, electric kettles, car bumpers and interior trim components, video cassette cases	Semi-rigid, translucent, good chemical resistance, tough, good fatigue resistance, integral hinge
Polystyrene (General Purpose) PS	BP Polystyrene Lacqrene Polystyrol Styron P	Toys and novelties, rigid packaging, refrigerator trays and boxes, cosmetic packs and costume jewellery, lighting diffusers, audio cassette and CD cases	Brittle, rigid, transparent, low shrinkage, low cost, excellent X-ray resistance, free from odour and taste, easy to process
Polystyrene (High Impact) HIPS	BP Polystyrene Lacqrene Polystyrol Styron	Yoghurt pots, refrigerator linings, vending cups, bathroom cabinets, toilet seats and tanks, closures, instrument control knobs	Hard, rigid, translucent, impact strength up to 7 x GPPS

Physical Properties

Material 1
		Unit
Tensile modulas	3.4	N/mm^2
Notched impact strength	5.5–12	Kj/m^2
Linear coefficient of expansion	110	x 10^6
Max cont use temp	90	°C
Specific gravity	1.41	

Producer: DuPont, Ticona

Resistance to Chemicals	
Dilute Acid	*
Dilute Alkalis	****
Oils and Greases	*** variable
Aliphatic Hydrocarbons	****
Aromatic Hydrocarbons	*** variable
Halogenated Hydrocarbons	*****

Cost: ££

Material 2
		Unit
Tensile modulas	2.4	N/mm^2
Notched impact strength	60–80	Kj/m^2
Linear coefficient of expansion	67	x 10^6
Max cont use temp	125	°C
Specific gravity	1.2	

Producer: Dow, GE Plastics, Bayer, DSM

Resistance to Chemicals	
Dilute Acid	***
Dilute Alkalis	***
Oils and Greases	****
Aliphatic Hydrocarbons	**
Aromatic Hydrocarbons	*
Halogenated Hydrocarbons	*
Alcohols	N/A

Cost: ££

Material 3
		Unit
Tensile modulas	2.5	N/mm^2
Notched impact strength	1.5–3.5	Kj/m^2
Linear coefficient of expansion	70	x 10^6
Max cont use temp	70	°C
Specific gravity	1.37	

Producer: BIP, DuPont, DuPont, DuPont, DSM

Resistance to Chemicals	
Dilute Acid	****
Dilute Alkalis	**
Oils and Greases	****
Aliphatic Hydrocarbons	****
Aromatic Hydrocarbons	**
Halogenated Hydrocarbons	**
Alcohols	****

Cost: ££

Material 4
		Unit
Tensile modulas	0.20–0.40	N/mm^2
Notched impact strength	no break	Kj/m^2
Linear coefficient of expansion	100–220	x 10^6
Max cont use temp	65	°C
Specific gravity	0.944–0.965	

Producer: Hoechst, Atochem, BASF, BP Chemicals, HD DSM

Resistance to Chemicals	
Dilute Acid	****
Dilute Alkalis	****
Oils and Greases	**variable
Aliphatic Hydrocarbons	*
Aromatic Hydrocarbons	*
Halogenated Hydrocarbons	*
Alcohols	

Cost: £

Material 5
		Unit
Tensile modulas	0.20–0.40	N/mm^2
Notched impact strength	no break	Kj/m^2
Linear coefficient of expansion	100–220	x 10^6
Max cont use temp	65	°C
Specific gravity	0.917–0.930	

Producer: BP Chemicals, Dow, Solvay Chemical

Resistance to Chemicals	
Dilute Acid	****
Dilute Alkalis	****
Oils and Greases	**variable
Aliphatic Hydrocarbons	*
Aromatic Hydrocarbons	*
Halogenated Hydrocarbons	*
Alcohols	****

Cost: £

Material 6
		Unit
Tensile modulas	0.95–1.30	N/mm^2
Notched impact strength	3.0–30.0	Kj/m^2
Linear coefficient of expansion	100–150	x 10^6
Max cont use temp	80	°C
Specific gravity	0.905	

Producer: Targor, Montell, BASF, DSM

Resistance to Chemicals	
Dilute Acid	****
Dilute Alkalis	****
Oils and Greases	**variable
Aliphatic Hydrocarbons	*
Aromatic Hydrocarbons	*
Halogenated Hydrocarbons	*
Alcohols	****

Cost: £

Material 7
		Unit
Tensile modulas	2.30–3.60	N/mm^2
Notched impact strength	2.0–2.5	Kj/m^2
Linear coefficient of expansion	80	x 10^6
Max cont use temp	70–85	°C
Specific gravity	1.05	

Producer: BP Chemicals, Atochem, BASF, Dow

Resistance to Chemicals	
Dilute Acid	*** variable
Dilute Alkalis	****
Oils and Greases	*** variable
Aliphatic Hydrocarbons	****
Aromatic Hydrocarbons	*
Halogenated Hydrocarbons	*
Alcohols	** variable

Cost: £

Material 8
		Unit
Tensile modulas	2.20–2.70	N/mm^2
Notched impact strength	10.0–20.0	Kj/m^2
Linear coefficient of expansion	80	x 10^6
Max cont use temp	60–80	°C
Specific gravity	1.03–1.06	

Producer: BP Chemicals, Atochem, BASF, Dow

Resistance to Chemicals	
Dilute Acid	**
Dilute Alkalis	****
Oils and Greases	**
Aliphatic Hydrocarbons	****
Aromatic Hydrocarbons	*
Halogenated Hydrocarbons	*
Alcohols	* variable

Cost: £

KEY * poor ** moderate *** good **** very good

Name	Trade names	Applications	Properties
Polysulphone (Family) PES, PEEK	Udel Ultrason Victrex PEEK	High and low temperature applications, microwave grills, electro/cryo surgical tools, aerospace batteries, nuclear reactor components	Outstanding oxidative stability at high temperature (-200°C to +300°C), transparent, rigid, high cost, requires specialised processing
Polyvinyl Chloride PVC	Solvic Evipol Norvinyl Lacovyl	Window frames, drain pipes, roofing sheets, cable and wire insulation, floor tiles, hosepipes, stationery covers, fashion footware, cling film, leathercloth	Rigid or flexible, clear, durable, weatherproof, flame resistant, good impact strength, good electrical insulation properties, limited low temperature performance
Polyurethane (Thermoplastic) PU Thermosets		Soles and heels for sports shoes, hammer heads, seals, gaskets, skate board wheels, synthetic leather fabrics, silent running gear	Flexible, clear, elastic, wear resistant, impermeable
THERMOSET PLASTICS Epoxies EP	Araldite Crystic Epicote	Adhesives, coatings, encapsulation, electrical components, cardiac pacemakers, aerospace applications	Rigid, clear, very tough, chemical resistant, good adhesion properties, low curing, low shrinkage
Melamines/ Ure (Aminos) MF, UF	Beetle Scarab	Decorative laminates, lighting fixtures, dinnerware, heavy-duty electrical equipment, laminating resins, surface coatings, bottle caps, toilet seats	Hard, opaque, tough, scratch resistant, self extinguishing, free from taint and odour, wide colour range resistance to detergents and dry cleaning solvents
Phenolics PF	Cellobond	Ashtrays, lamp holders, bottle caps, saucepan handles, domestic plugs and switches, welding tongs and electrical iron parts	Hard, brittle, opaque, good electrical and heat resistance, resistant to deformation under load, low cost, resistant to most acids
Polyester (unsaturated) SMC, DMC, GRP	Beetle Crystic Synoject	Boat hulls, building panels, lorry cabs, compressor housing, embedding, coating	Rigid, clear, chemical resistant, high strength, low creep, good electrical properties, low temperature impact resistance, low cost
Polyurethane (cast elastomers) EP		Printing rollers, solid tyres, wheels, shoe heels, car bumpers, (particularly suited to low-quantity production runs)	Elastic, abrasion and chemical resistant, impervious to gases, can be produced in a wide range of hardnesses

Physical Properties			Producer	Resistance to Chemicals		Cost
Tensile modulas	2.10–2.40	N/mm^2	Amoco	Dilute Acid	****	£££
Notched impact strength	40.0–no break	Kj/m^2	BASF	Dilute Alkalis	****	
Linear coefficient of expansion	45–83	x 10^6	Victrex	Oils and Greases	****	
Max cont use temp	160–250	°C		Aliphatic Hydrocarbons	** variable	
Specific gravity	1.24–1.37			Aromatic Hydrocarbons	*	
				Halogenated Hydrocarbons	*	
				Alcohols	****	
Tensile modulas	2.6	N/mm^2	Solvay Chemical	Dilute Acid	****	£
Notched impact strength	2.0–45	Kj/m^2	EVC	Dilute Alkalis	****	
Linear coefficient of expansion	80	x 10^6	Hydro Polymers	Oils and Greases	*** variable	
Max cont use temp	60	°C	Elf Atochem	Aliphatic Hydrocarbons	****	
Specific gravity	1.38			Aromatic Hydrocarbons	*	
				Halogenated Hydrocarbons	** variable	
				Alcohols	*** variable	
Tensile modulas	n/a	N/mm^2		Dilute Acid	n/a	££
Notched impact strength	n/a	Kj/m^2		Dilute Alkalis	n/a	
Linear coefficient of expansion	n/a	x 10^6		Oils and Greases	n/a	
Max cont use temp	n/a	°C		Aliphatic Hydrocarbons	n/a	
Specific gravity		n/a		Aromatic Hydrocarbons	n/a	
				Halogenated Hydrocarbons	n/a	
				Alcohols	n/a	
Tensile modulas	n/a	N/mm^2	Ciba Geigy	Dilute Acid	n/a	£££
Notched impact strength	n/a	Kj/m^2	Scott Bader	Dilute Alkalis	n/a	
Linear coefficient of expansion	n/a	x 10^6	Shell	Oils and Greases	n/a	
Max cont use temp	n/a	°C		Aliphatic Hydrocarbons	n/a	
Specific gravity		n/a		Aromatic Hydrocarbons	n/a	
				Halogenated Hydrocarbons	n/a	
				Alcohols	n/a	
Tensile modulas	n/a	N/mm^2	BIP Chemicals	Dilute Acid	n/a	£
Notched impact strength	n/a	Kj/m^2	BIP Chemicals	Dilute Alkalis	n/a	
Linear coefficient of expansion	n/a	x 10^6		Oils and Greases	n/a	
Max cont use temp	n/a	°C		Aliphatic Hydrocarbons	n/a	
Specific gravity		n/a		Aromatic Hydrocarbons	n/a	
				Halogenated Hydrocarbons	n/a	
				Alcohols	n/a	
Tensile modulas	n/a	N/mm^2	BP Chemicals	Dilute Acid	n/a	££
Notched impact strength	n/a	Kj/m^2		Dilute Alkalis	n/a	
Linear coefficient of expansion	n/a	x 10^6		Oils and Greases	n/a	
Max cont use temp	n/a	°C		Aliphatic Hydrocarbons	n/a	
Specific gravity		n/a		Aromatic Hydrocarbons	n/a	
				Halogenated Hydrocarbons	n/a	
				Alcohols	n/a	
Tensile modulas	n/a	N/mm^2	BIP Chemicals	Dilute Acid	n/a	£
Notched impact strength	n/a	Kj/m^2	Scott Bader	Dilute Alkalis	n/a	
Linear coefficient of expansion	n/a	x 10^6	Cray Valley	Oils and Greases	n/a	
Max cont use temp	n/a	°C		Aliphatic Hydrocarbons	n/a	
Specific gravity		n/a		Aromatic Hydrocarbons	n/a	
				Halogenated Hydrocarbons	n/a	
				Alcohols	n/a	
Tensile modulas	n/a	N/mm^2	ICI	Dilute Acid	n/a	££
Notched impact strength	n/a	Kj/m^2	Shell	Dilute Alkalis	n/a	
Linear coefficient of expansion	n/a	x 10^6	Dow	Oils and Greases	n/a	
Max cont use temp	n/a	°C		Aliphatic Hydrocarbons	n/a	
Specific gravity		n/a		Aromatic Hydrocarbons	n/a	
				Halogenated Hydrocarbons	n/a	
				Alcohols	n/a	

KEY * poor ** moderate *** good **** very good

Additives	A wide range of substances that help in the processing of parts or in the physical and chemical properties of a final product. The additives are added to the basic resins by the resin supplier before being supplied to the production plant. Examples of additives include UV stabilisers, anti–bacterial additives, flame retarders, dyes and pigments, photochromics, reinforcing fibres and plasticisers.
Blends	Blends can be used to tailor-make plastics with specific characteristics that cannot be achieved by a single polymer. They are a physical blend of two or more polymers to form materials with a combination of characteristics of both materials. Typical and common blends include: ABS/PC, ABS/polyamide, PC/PP PVC/ABS. Blends are an additional form of tailoring polymers to those created by co-polymerisation and differ from co-polymers in that they are physical mixtures, not chemical.
Commodity plastics	Another way of dividing plastics is by categorising them as either engineering plastics or commodity plastics. Commodity plastics have relatively low physical properties and are commonly used in the production of everyday low-cost products. This classification group includes vinyls, polyolefins and styrenes.
Co-polymers	The mixing of two or three compatible monomers, in order to form a new chemical compound which can be used to create a material which has a combination of the qualities of both monomers. This differs from a blend in that they are not physical but chemical mixtures.
Elasticity	The amount a material recovers to its original shape and size after it has been deformed. This is different to the testing of plastic behaviour, which describes the way a material stretches and does not return to its original shape or size.
Elastomers	Elastomers are rubber-like materials but with far more processing potential. They can be processed in the same way as thermosetting materials. Elastomers may feel like rubbers but technically differ by their ability to return to their original length once they have been deformed, rubber being able to return to its original shape more quickly and easily.
Engineering plastics	There are a number of ways of classifying plastics: thermoplastic/thermoset, amorphous/crystalline. Paired with commodity plastics, engineering plastics are another way of categorising plastics. They are generally a much higher cost with superior physical, chemical and thermal characteristics and used in applications with demanding environments. They include acetals, acrylics, polyamides and polycarbonates.
Fillers	Fibrous materials like glass and carbon which give enhanced mechanical properties like stiffness. Non-fibrous materials fillers like hollow spheres can be used to reduce the overall weight of a part.
Hardness	The ability of a material to withstand indentation and scratching. The most common tests are the Rockwell and Durometer tests which are graded in Shore hardness from Shore A soft to Shore D hard. Examples of hard plastics include melamine, urea and phenolic formaldehydes and PET. Low-density polyethylene and elastomers are examples of soft plastics.
Impact resistance	A material's ability to absorb energy. The final product is determined also by shape, thickness and temperature. The Izod test for strength involves a sample of material being clamped to a base while a weighted pendulum is allowed to swing over a raised area of the sample, to see at what point the sample would snap.
Monomers	The individual molecules which when joined together form a polymer chain.
Plastic	The true definition of plastic does not describe a specific material but how a material acts. In common language polymers are known as plastic due to the way they behave physically i.e. their shape can be easily changed.
Polymer	A flexible, long chain of monomer molecules which display different characteristics according to the chemistry of the monomers and the size and shape of the molecules.
Polyolefins	This important group of polymers is made up of polyethylenes and polypropylene. Polyolefins account for the largest produced plastics in the world accounting for 45% of plastic production. Together with vinyls and styrenes, polyolefins are classified as commodity plastics.

Resins	**Generally used to describe the basic polymerised material e.g. polystyrene, ABS, which can also be described as polymers.**
Tensile strength	**The maximum pulling strain that can be applied to a material before it fractures.**
Thermoplastic	**Another major classification type for plastics. A material that by the action of heat can be softened, melted and re-formed without any change in properties. This means that off-cuts and scrap from manufacturing processes can be re-ground and re-used and products made from thermoplastics can be easily recycled. The shape of thermoplastic's molecules is linear, allowing them to move easily under heat and pressure.**
Thermoset plastics	**One of the major ways of classifying plastics. Thermosetting plastics do not soften when heated and cannot be re-used. Due to this characteristic they do not have the same processability of thermoplastics. As opposed to thermoplastics their molecules form a cross-linked network that limits movement within the chains.**

Glossary

Abbreviations				
	ABS	**Acrylonitrile-Butadiene-Styrene**	PES	**Poly (Ether Sulphone)**
	ASA	**Acrylonitrilelstyrene-Acrylate**	PET	**Polyethylene Terephthalate**
	ACS	**Acrylonitrile Styrene**	PI	**Polyimides**
	AES	**Acrylonitrile Styrene/EP (D) M Rubber**	PF	**Phenol-Formaldehyde (Phenolics)**
	BMC	**Bulk-Moulded Compound**	PMMA	**Polymethyl Methacrylate (Acrylic)**
	CA	**Cellulose Acetate**	POM	**Polyoxymethylene (Polyacetal)**
	CAP	**Cellulose Acetate Propionate**	PP	**Polypropylene**
	DMC	**Dough-Moulding Compound**	PPE	**Poly (Phenylene Ether)**
	EETPE	**Copolyester Ether Thermoplastic Elastomer**	PS	**Polystyrene**
	EP	**Epoxy**	PSU	**Polysulphone**
	EVA	**Ethylene Vinyl Acetate**	PTFE	**Polytetrafluoroethylene**
	HDPE	**High-Density Polyethylene**	PU	**Polyurethane**
	HIPS	**High-Impact Polystyrene**	PVC	**Poly (Vinyl Chloride)**
	LDPE	**Low-Density Polyethylene**	PVC/PVC	**Plasticised Poly (Vinyl Chloride)**
	MF	**Melamine Formaldehyde**	SAN	**Styrenelacrylonitrile**
	OTPE	**Olefinic Thermoplastic Elastomer**	SB	**Styrene Butadiene**
	PA	**Polyamide (Nylon)**	SBS	**Styrenelbutadiene-Styrene Block Co-polymer**
	PBT	**Poly (Butylene Terepthalate)**	SI	**Silicone**
	PC	**Polycarbonate**	TPU	**Thermoplastic Polyurethane**
	PE	**Polyethylene**	TPO	**Thermoplastic Polyolefin**
	PEEK	**Polyetheretherketone**	UP	**Unsaturated Polyester**

www.americanplasticscouncil.org

The American Plastics Council (APC) is a major trade association for the US Plastics Industry. APC works to promote the benefits of plastics and the plastics industry. Lots of relevant information on anything you need to know about plastics. Includes news, education, plastics and the environment.

www.deutsches-kunststoff-museum.de

German Plastics Museum.

www.materials.org.uk

The Institute of Materials serves the international materials community through its wide range of learned society activities and by acting as the professional body for materials scientists and engineers.

www.plastics-museum.com

The site for discovering everything you have ever wanted to know about the history of plastics from 1284 to the present day. Find out about blood and sawdust, shellac and Bakelite, Bandalasta and Barbie. This is an ideal site for designers, collectors, curators, conservators and students of our industrial and cultural plastics heritage.

www.bpf.co.uk

The British Plastics Federation is the trade association representing the UK plastics industry.

www.pras.com

Website for the plastics and rubber advisory service. Gives online help with finding plastic producers in the UK.

www.polymer-age.co.uk

British plastics and rubber. Latest news in the plastics industry. Also has up-to-date resin prices.

www.vinylinfo.org

Website for The Vinyl Institute.

www.polystyrene.org

Website for the Polystyrene Packaging Council.

www.polyurethane.org

Alliance for the Polyurethanes Industry.

www.plasticsindustry.org

Website for the Society of Plastics Industry. Information on processing methods, history of plastics, economic statistics.

www.4spe.org

The Society of Plastics Engineers.

www.socplas.org

The Society of the Plastics Industry, founded in 1937. The Society of the Plastics Industry is the trade association representing the fourth largest manufacturing industry in the United States. The SPI's 1,600 members represent the entire plastics industry supply chain, including processors, machinery and equipment manufacturers, and raw material suppliers.

Types of plastic

www.ecvm.org

European-based company giving information on PVC.

www.vinyl.org

A whole range of information on vinyls.

www.siliconesolutions.com

www.appliedsilicone.com

www.silicone-rubber.com.tw

Education

www.teachingplastics.org

Information on the teaching of plastics in schools.

www.psrc.usm.edu

The School of Polymers and High Performance Materials at The University of Southern Mississippi in Hattiesburg, MS. Check out macrogalleria at cyberwonderland of polymer fun and also the Polyquarium "Polymers from the Sea".

www.irc.leeds.ac.uk/irc/miscellaneous/faq/faq.htm

General information about plastics.

Experts

www.modplas.com

Modern Plastics is the most powerful, credible, and respected information company serving the worldwide plastics industry.

www.apgate.com

Directory for industry and technology in the UK and Ireland. The Applegate Directory has information on more than 16,000 companies and receives more than 20 million page views each year. This is the leading directory for the electronics, engineering, and the plastics and rubber industry sectors in the UK.

www.polymer-search.com

PSI is a free internet search engine dedicated to the polymer industries. Only sites that offer considerable content directly related to rubber, plastics or adhesives are indexed.

www.rapra.com

Rapra Technology is Europe's leading independent plastics and rubber consultancy. Rapra provides comprehensive consultancy, technology, and information services for the polymer industry and industries using plastics and rubber in any component, product or production process.

www.matweb.com

MatWeb has detailed property information on 20,000 entries including metals (aluminum, steel, etc.), polymers (Nylon, polyester, etc.), ceramics, and other engineering materials.

www.ecomplastics.com

For 87 years Ridout Plastics/Clear Presentations has served the world with plastics materials and manufacturing services. Ridout Plastics' core competency is the ability to innovatively solve customer problems using plastics.

www.tangram.co.uk/index.htm

Consulting and engineering for plastics Tangram Technology provides high-quality training, technical writing, change management, product design and field services to all areas of the plastics products and window industries.

www.plastics.com

Websites of plastics firms and general plastic information.

www.plasticsnet.com

Easy-to-use search engine for plastic-related supplies in the US.

www.polymers-center.org

If you process, manufacture, purchase, design, test materials, or need technical assistance with products using plastic or rubber, the Polymers Center of Excellence can help trim costs and improve productivity.

wwwhere.else

www.amiplastics.com

AMI is Europe's largest market research consultancy providing research, consulting and analytical services to the global plastics industry. AMI is also a major publisher of both commercial and technical information for the plastics industry.

Plastic Producers

www.glscorporation.com

GLS is both a custom compounder and a distributor of soft, flexible thermoplastic elastomers for injection moulding and extrusion. These unique products are offered to designers for ergonomic, soft-touch and flexible applications. Primary markets are sporting goods, housewares, hardware, packaging, personal care, medical and general industrial.

www.lnp.com

LNP produces cost-effective, high performance thermoplastic compounds. Their goal is to help customers refine the effects of base resins through electrical and thermal activity, lubricity, structural strength, dimensional stability, and colour accuracy.

www.eastman.com

Eastman Chemical Company (NYSE:EMN) is a leading international chemical company that produces more than 400 chemicals, fibres and plastics. Eastman is the world's largest supplier of polyester plastics for packaging and a leading supplier of coatings for raw materials.

www.bayerus.com/plastics/products/index.html

Website for Bayer polymers division.

www.asresin.com

Honeywell Engineered Applications & Solutions is a source for Nylon and PET resins. On this website you can find the information you need to select resins, place orders, troubleshoot your processing, discover new ideas, learn about technologies, get help with design, and arrange testing of your application's performance.

www.basf.com/businesses/polymers/plastics

BASF polymer site.

www.ashleypoly.com

Ashley Polymers has a full range of engineered resins, ranging from premium lines to economy materials.

www.nowplastics.com

NOW Plastics is a full-service company with the ability to locate, market, finance, warehouse and transport virtually any kind of plastic film or packaging material in the world.

www.vink.com/index.html

One of the broadest assortments of semi-finished plastics in Europe. Plastic products in basic forms like sheets, films and blocks, as well as tubes and fittings.

www.plastics-car.com

Plastic applications in cars.

www.finishingsearch.com

Search engine for paint, powder, and finishing.

www.plasticsnet.matweb.com/tradename.htm

Excellent for searching trade names and plastics manufacturers.

www.novachem.com/ourproducts/styrenics.cfm

NOVA Chemicals Corporation, headquartered in Calgary, Alberta, Canada is a focused commodity chemical company, producing styrenics and olefins/polyolefins at 18 locations in the United States, Canada, France, the Netherlands and the United Kingdom.

www.v-tec.com

Suppliers of coatings that include hardcoats, UV-cured hardcoats, weather hardcoats, anti-fog, metallic, electrostatic dissapative, anti-static, anti-glare, UV blocking, laser blocking, photochromic.

www.solaractiveintl.com

Products that change colour in the sunlight.

www.davisliquidcrystals.com

Colour-changing polymers.

www.distrupol.com

Distrupol is a leader in polymer distribution throughout Europe and a partner to some of the world's finest polymer producers.

www.burallplastec.com

Specialist printers and fabricators of plastic sheet material.

www.medicalrubber.se

Medical Rubber develops and produces moulded precision components to customer specifications, in liquid silicone rubber and thermoplastic elastomers (TPE). Their operations comprise two divisions – health care, including clean-room production, and industrial.

www.interactivecolors.com

The first company to develop thermochromic offset ink which can be used with existing offset printing with only minor changes.

www.plasticmaterials.com

Plastic Materials for Industry supply high-quality virgin resins to resin processors.

www.sdplastics.com

San Diego Plastics, Inc. is a distributor of plastic sheet, rod, tube and film. They supply formed, machined, or fabricated parts to your specifications, including phenolic sheet and teflon tubes and fittings.

www.globalcomposites.com

Global Composites is a worldwide interface set up to facilitate use of composite materials between the composite industries and other industries (aeronautics, automotive, construction).

www.dielectrics.com/do.html

Dielectrics Industries designs, develops, and fabricates components and finished products on a contract manufacturing basis utilising films, laminates, and specialised performance materials. The components and finished products typically include RF welded bladders which are either air-, fluid-, or gel-filled.

www.dow.com/plastics/index.htm

Dow Plastics offers one of the broadest ranges of thermoplastics and thermosets globally. A leading manufacturer of polyethylene, polystyrene, and polyurethanes, they also supply engineering plastics such as ABS and polycarbonate, polypropylene and more.

www.sealedair.com

Sealed Air Corporation is a leading global manufacturer of materials and systems for protective, presentation, and fresh food packaging in the industrial, food, and consumer markets.

www.vtsdoeflex.co.uk

VTS Doeflex specialises in producing a wide range of thermoplastic materials for thermoforming, fabricating and printing.

www.vitathermoplasticsheet.com

VTS – Vita Thermoplastic Sheet – is the thermoplastic sheet operation of British Vita PLC. British Vita is a major public company with worldwide interests in foams, fibres, plastic compounds and sheet.

www.plaslink.com

A UK-based company, the All Plastic Part & Product Database has been set up to enable designers and manufacturers to search for specific products and plastic parts, both by keyword and usage categories.

www.apme.org

APME is the voice of the plastics manufacturing industry, representing over 40 member companies which in turn represent over 90 per cent of Western Europe's polymer production capacity.

Plastics and the environment

www.plasticsresource.com

Information on plastics and the environment, conservation, recycling etc.

www.plasticsinfo.org

Plastics and your health.

www.recoup.org

The UK's household plastic container recycling organisation. Facilitates, promotes and educates about post-consumer plastic container recycling in the UK. Good education section.

www.plasticx.com

A free worldwide electronic information exchange service for scrap plastic recycling.

www.home-recycling.org

Waste awareness in the home. A compendium of tips and hints on waste reduction recycling.

www.n6recycling.com

Recyclers of Nylon.

www.iavicopolymers.com

Helps companies recycle large amounts of scrap.

www.cawalker.co.uk

Plastic recycling.

pp4–5, with thanks and acknowledgement to Bobo Designs; pp6–7 coat hanger, with thanks and acknowledgement to Marc Newson Ltd.; p8 3D Lamp, with thanks and acknowledgement to Francois Azambourg and Valorisation de l'Innovation dans l'Ameublement; p14 Quoffee stool, with thanks and acknowledgement to Rainer Spehl; p15 Traffic cone, with thanks and acknowledgement to Swintex Ltd.; pp16–17 Orgone chair, with thanks and acknowledgement to Mark Newson Ltd.; p18 MAXiM bench, with thanks and acknowledgement to Catherine Froment and Valorisation de l'Innovation dans l'Ameublement; p19 Pack chair, with thanks and acknowledgement to François Azambourg and Valorisation de l'Innovation dans l'Ameublement; p20 Smart Car, with thanks and acknowledgement to Smart Car; p22 Oz fridge, with thanks and acknowledgements to Zanussi and Roberto Pezzetta; p23 Wee Willie Winkie with thanks and acknowledgement to Chris Lefteri and Dominic Jones; pp24–25 Bookworm and chair, with thanks and acknowledgement to Ron Arad and Kartell; p26 Amazonia vase, with thanks and acknowledgement to Gaetano Pesce and Fish; p27 Baja, with thanks and acknowledgement to Michael Van Steenburg and Automotive Design and Composites; pp28–29 Upper, with thanks and acknowledgement to Kartell, Alberto Meda and Paulo Rizzatto; p30 Light Light chair, with thanks and acknowledgement to Alias S.r.l. and Alberto Meda; p31 Miss Blanche chair, with thanks and acknowledgement to The Montreal Museum of Modern Art, USA; p34 Australian dollars, with thanks and acknowledgement to The Federal Reserve Bank of Australia, photography by Xavier Young; p35 Identity Crisis, with thanks and acknowledgement to Thomas Heatherwick Design, photography by Steve Speller; p37 Bento Box, with thanks and acknowledgement to Toni Papaloizou, Chris Lefteri and Mash and Air, UK; p38 Netlon, with thanks and acknowledgement to Netlon Ltd. and Alison Lefteri; p39 Baladeuse with thanks and acknowledgement to IXI, Izumi Kohama and Xavier Moulin; pp40–41 Airwave, with thanks and acknowledgement to Bobo Designs, Tanya Dean and Nick Gant; pp42–43 Pianomo, with thanks and acknowledgement to Shun Ishikawa, Ringo with thanks and acknowledgement to Matthew Jackson, W Table with thanks and acknowledgement to Adrian Tan; pp45–46 Tummy and Bow bag and Spine Knapsack, with thanks and acknowledgement to Karim Rashid, New York and Issey Miyake, Japan; p47 Colourscape, with thanks and acknowledgement to Peter Jones and Colourscape; p48 Sicoblock with thanks and acknowledgement to Mazzucchelli, material photographed by Xavier Young, p49 Ultra Luz, with thanks and acknowledgement to Marco Souza Santos, Pedro S. Dias and Proto Design; p51 Table light, with thanks and

acknowledgement to Inflate and Nick Crosbie; pp52–53 Airmail dress, with thanks and acknowledgement to Hussein Chalayan, photography by Xavier Young; pp54–55 Corian®, with thanks and acknowledgement to Sheila Fitzjones PR Consultancy, DuPont, Gitta Gschwendtner and Fiona Davidson; pp58–59 Soft Lamp, with thanks and acknowledgement to Droog Design, Holland and Arian Brekveld; p60 Swingline Stapler, with thanks and acknowledgement to Acco and Scott Wilson; p61 Screwdriver with thanks and acknowledgement to Acordis, photography by Xavier Young; pp62–63 Contenants, with thanks and acknowledgement to Dela Lindo; p65 Flexilight, with thanks and acknowledgements to Wideloyal Industries Ltd., photography by Xavier Young; p66 Posacenere, with thanks and acknowledgement to Kartell and Anna Castelli Ferrieri; p67 Radius toothbrush, with thanks and acknowledgement to Radius, photography by Xavier Young; pp68–69 Not Made by Hand, Not Made in China, with thanks and acknowledgement to Ron Arad and Associates; p70 Tasting spoon, with thanks and acknowledgement to Sebastian Bergne; p71 Can Can, with thanks and acknowledgement to Alessi and Stefano Giovanonni; p72 FABFORCE™ fins, with thanks and acknowledgement to Bob Evans; p73 Soapy Joe, with thanks and acknowledgement to W2 and Jackie Piper and Vicki Whitbread; p75 'Very' CD case, with thanks and acknowledgement to Parlophone Records and Daniel Weil; pp76–77 iMac, with thanks and acknowledgement to Jonathan Ive and Apple Computer; p78 Will, with thanks and acknowledgement to Ayoshi Co. Ltd.; Beer bottles, with thanks and acknowledgement to Miller Brewing Company, photography by Xavier Young; p82 Kevlar® sole with thanks and acknowledgement to DuPont; p83 Delrin® clothes pegs, with thanks and acknowledgement to DuPont; p84 Technogel® saddle, with thanks and acknowledgement to Selle Royale; p86 James doorstop, with thanks and acknowledgement to Klein and More, photography by Xavier Young; p87 Light Light, with thanks and acknowledgement to Takeshi Ishiguro, photography by Richard Davis; p89 Airwave Bobo designs, with thanks and acknowledgement to Tanya Dean and Nick Gant; p90 Hytrel®, with thanks and acknowledgement to DuPont; p91 Zytel® Nike shoe, with thanks and acknowledgement to Nike and DuPont; pp92–93 Lamp, with thanks and acknowledgement to François Azambourg and Valorisation de l'Innovation dans l'Ameublement; p94 c360 Security Light, with thanks and acknowledgement to Mark Greene; p95 Silly Putty, Silly Putty and The Real Solid Liquid are registered trademarks of Binney & Smith, used with permission, photography by Xavier Young; p97 Attila, with thanks and acknowledgement to Rexite Spa and Julian Brown; p98 ElecTex™ conference phone, with thanks and

acknowledgement to ElecTex™; p99 La Mairie, with thanks and acknowledgement to Kartell and Philippe Starck; pp100–101 Rolatube™, with thanks and acknowledgement to Rolatube™; pp104–105 Made of Waste, with thanks and acknowledgement to Smile Plastics, photography by Xavier Young; pp106–107 biodegradable sacks, with thanks and acknowledgement to Symphony Environmental, bag photography by Xavier Young, pp108–109 Grot, with thanks and acknowledgement to Grot Global Resource Technology, photography by Xavier Young; pp110–111 Riedizioni bags, with thanks and acknowledgement to Luisa Cevese, Riedizioni; p112 Remarkable Pencils, with thanks and acknowledgement to Re-markable Pencils Ltd. and Frost Design; p116 Maxfli, with thanks and acknowledgement to Dunlop Slazenger; p117 Flexboard, with thanks and acknowledgement to Man and Machine Inc.; pp118–119 Bowling balls, with thanks and acknowledgement to Brunswick; p120 Snooker Balls, with thanks and acknowledgement to Aramith® and Saluc S.A.; p121 Lockheed F-80C, with thanks and acknowledgement to Airfix and Nicholas Kove, photography by Xavier Young; pp122–123 Eiffel Tower Jelly, with thanks and acknowledgement to Patrick Cox; Jelly shoes; with thanks and acknowledgement to Pam Langdown; p124 Sonata with thanks and acknowledgement to Polypipe Bathroom and Kitchen Products Ltd.; p125 Wondelier bowl set, Tupperware, with thanks and acknowledgement to Stewart Grant/Katz Collection; p126 Jumo desk lamp, with thanks and acknowledgement to Stewart Grant/Katz Collection; p127 Plastic cork with thanks and acknowledgement to Supremecorq®; pp130–131 Lunch box and drinks bottle, with thanks and acknowledgement to Solar Active™, photography by Xavier Young; p132 Visual Effects®, with thanks and acknowledgement to DuPont, photography by Xavier Young; p138 Egg cup, with thanks and acknowledgement to Inflate; p137 Traffic cone, with thanks and acknowledgement to Swintex Ltd.; Tapis Vert, with thanks and acknowledgement to BOBDESIGN; p138 Australian dollar, with thanks and acknowledgement to The Federal Reserve Bank of Australia, photography by Xavier Young; Posacenere, with thanks and acknowledgement to Kartell and Anna Castelli Ferrieri; p139 Flexboard, with thanks and acknowledgement to Man and Machine Inc.; p140 Orgone chair, with thanks and acknowledgement to Mark Newson Ltd; Swingline Stapler, with thanks and acknowledgement to Acco and Scott Wilson; p141 Bento Box, with thanks and acknowledgement to Toni Papaloizou, Chris Lefteri and Mash & Air, UK; pp142–143 illustrations by Daniel White.

Thank you

There are so many people over the last year who have helped me through their enthusiasm, ideas and suggestions for this most special project. My thanks to my wife Alison who has been my constant guide and tester of ideas. To Zara Emerson at RotoVision for having the faith in me at the beginning, her amazing enthusiasm and total understanding of everything this book should be and for her being the best editor I could have wished for. A million bucket loads of thanks to Laura Owen and Nicole Mendelsohn for their enthusiasm, support, help and ideas, and without whose help I could not have finished this book on time. Thanks also for listening to me in my times of panic. Ben and KC for their ideas, feedback and friendship. To little shoe — I love you.

To Mark, Shun and especially Odile for the phone calls to France and Japan. To Toni for bringing me into the profession and his guidance over the last 15 years. To materials man Alan Baker for all his help and contacts. To Early for the feedback. To Piotre for the contact. To Simon B for his support and letting me go home and not to the pub to write this book. Ali, there are too many things to thank you for over the last 15 years. To Dominic for his friendship and sowing the seeds for this idea of a book. To Andrew Wilkins at DuPont. To Pam Langdown at The Design Collection at The Arts Institute at Bournemouth for the Jelly shoes. Norman Merry at the British Plastics Federation for being very helpful and generous with his knowledge. To all the many people from various companies I have spoken to on the phone over the last year and have provided me with invaluable technical help and guidance. To all of my family.

Luton Sixth Form College
Learning Resources Centre

Index

Luton Sixth Form College
Learning Resources Centre

WITHDRAWN